IMAGES
of America

DETROIT'S HISTORIC
DRINKING ESTABLISHMENTS

On the cover: Three young newspaper boys find a spot of shade in the doorway of the Point Café on Jefferson Avenue during July 1915. (Courtesy of the Burton Historical Collection, Detroit Public Library.)

IMAGES
of America

DETROIT'S HISTORIC DRINKING ESTABLISHMENTS

Victoria Jennings Ross

Copyright © 2008 by Victoria Jennings Ross
ISBN 978-0-7385-6191-2

Published by Arcadia Publishing
Charleston SC, Chicago IL, Portsmouth NH, San Francisco CA

Printed in the United States of America

Library of Congress Catalog Card Number: 2008928818

For all general information contact Arcadia Publishing at:
Telephone 843-853-2070
Fax 843-853-0044
E-mail sales@arcadiapublishing.com
For customer service and orders:
Toll-Free 1-888-313-2665

Visit us on the Internet at www.arcadiapublishing.com

This book is dedicated to my father, J. J. Jennings, a master storyteller who shared with his daughter a lifelong enthusiasm for Detroit history.

Contents

Acknowledgments		6
Introduction		7
1.	Detroit's Early Taverns	9
2.	From Frontier Town to Travel Destination	17
3.	The Era of the Elegant Saloon	39
4.	Detroit's Cigar Industry	75
5.	Detroit's Brewing Industry	79
6.	Temperance and Prohibition	85
7.	The Era of the Cocktail Lounge	103

Acknowledgments

Luckily for me, Detroit's cultural and research institutions are staffed by extremely capable and good-natured professionals. Without their help, the research for this book would have remained packed away in an acid-free box in my attic. I would like to thank my friends at the Detroit Historical Museum: Marianne Weldon was the first to suggest that I publish my research on Detroit leisure; Joel Stone generously shared with me his considerable research on Detroit's early taverns; and David Schneider helped me navigate the museum's considerable archival holdings. Mary Wallace at Wayne State University's Walter P. Reuther Library helped me sort through hours of newsreels in the Virtual Motor City Collection. Mark Patrick, Mark Bowden, and the rest of the patient and knowledgeable librarians at the Burton Historical Collection spent countless hours helping me locate images and scan photographs. I am also very grateful to a number of extraordinary individuals who shared information with me and whose stories are critical to Detroit's entertainment and business history. They are Joe Muer, John Stroh, Skip Roberts, Carlos Alvarez, John Butsicaris, and Maxine Behem and family. S. R. Boland provided me with valuable insight on the history of Detroit's music scene. Jon M. Kingsdale's 1973 article titled "Poor Man's Club" proved to be an invaluable source on the social implications of the urban saloon. I am also grateful to my friends Jim Tottis, Mike Crane, and Tim Burns in the Department of American Art at the Detroit Institute of Arts for their friendship and for sharing with me their knowledge of and love for the arts in Detroit. Finally, I would like to thank my wonderful husband and three children for putting up with me; I can only hope that I make you as proud of me as I am of all of you.

INTRODUCTION

I spend my childhood playing in the grassy parks of the affluent Detroit suburb of Grosse Pointe Farms, but the excitement and bustle of the nearby downtown loomed large in my consciousness. My father, who was born at home in the 1920s on a street not far from where I biked daily with neighborhood friends, filled my head with tales of the escapades of legendary Detroiters and walked me down the city streets pointing out landmarks until my feet grew tired. It is not surprising, then, that my father's love affair with Detroit soon became my own. As fate would have it, my life came full circle after spending a number of years after graduate school on the East Coast; my husband took a job in Detroit, and I was able to return to the city that had meant so much to me as a child.

Three different flags have flown over Detroit throughout its history: the French, the British, and the American. French explorers arrived in Detroit in July 1701, intent on making a fortune in the fur trade and erecting western outposts to keep the competition—the British—at bay. The area's abundance of natural resources and close proximity to water had long distinguished it as a perfect location for trade and the presumed gateway to America's western territory and beyond. The French laid claim to the land by erecting Fort Pontchartrain du Detroit above the river at its narrowest part. It was on this site that the city of Detroit had its beginnings as a fur-trapping outpost, growing into a frontier town after the arrival of the steamships and, finally, into a thriving manufacturing center.

Throughout the 18th century, Detroit remained a small and somewhat forbidding wilderness outpost. Thanks to constant reports of illness and American Indian attacks, Detroit's population grew imperceptibly during the mid-1700s, but the French citizens who did emigrate spared no expense in accumulating and supplying themselves with the best attire, food, and drink that France could provide. They dined and drank at home, holding formal balls and dances that ran late into the night. The arrival of the British in 1760 did little to deter French entertaining habits; they merely incorporated the new residents into their at-home revelry. But the British also introduced Detroiters to a new kind of drinking and dining establishment outside the home—the tavern. These gathering places began opening up on the river at what was now the center of old Detroit, at Jefferson Avenue and Randolph Street. Run by retired military men, taverns focused on servicing permanent residents rather than transients; the few visitors who came to Detroit usually stayed in private residences. Early taverns, also known as public houses, were more than just places to socialize, to eat, and to drink, however. Citizens also went to places like Forsyth's and Dodemead's to vote in rudimentary elections and to participate in political meetings.

Detroit suffered a devastating fire in 1805 that left only one wooden building standing in the old city center. That year, Judge Augustus B. Woodward submitted a plan based on the one used for Washington, D.C, which consisted of boulevards running north, south, east, and west at right angles like the spokes of a wheel. The plan seen in the Detroit of today remains fairly consistent to the arrangement proposed by Woodward.

By 1819, Detroit had made the transition from isolated outpost to growing town. Steamships began to make regular trips to the docks on the Detroit River in the early 1820s, bringing travelers eager to experience the western frontier firsthand. The influx of visitors necessitated the building of hotels to accommodate visitors, and the city had to shift its focus from serving residents to providing temporary quarters for nonresidents. The Steamboat Hotel, the Biddle House, and other businesses continued to play the civic role established for the tavern by Forsyth's and Dodemead's, hosting elections, rallies, and political meetings.

In 1857, the elegant Russell House opened on Woodward Avenue at the Campus Martius (from the Latin meaning "field of Mars," where the Roman heroes walked). Woodward designated this as the heart of the city, where Michigan Avenue, Monroe Street, Cadillac Square, Fort Street, and Woodward Avenue intersect. A flurry of hotels, theaters, saloons, and businesses sprang up shortly thereafter in this part of town. For the first time since its beginning, Detroit's geographic center had shifted away from the riverfront, and a steady migration northward had begun up Woodward Avenue. By the late 1870s, the city experienced another type of migration—that of German, Polish, Jewish, Greek, Hungarian, Irish, and other immigrants arriving from Europe. Detroit's new residents lost no time in opening up breweries, cigar factories, and other trades they had practiced in their homelands.

Woodward Avenue continued to flourish as the center for drinking, dining, and theatergoing. By 1907, Detroit was known as "a city of saloons" (over 1,300, to be exact), but the prosperity of these places was to be short-lived; with Michigan's adoption of the Volstead Act in 1918, Detroit's drinking establishments had to close their doors. Of course, Prohibition did little to discourage people from obtaining liquor through illegal means. If alcoholic beverages could not be made at home, they could be bought from parked cars, obtained in Canada, or consumed in the speakeasies and blind pigs that popped up on every Detroit street. No doubt, the nation breathed a collective sigh of relief in 1933 when the Volstead Act was repealed. The era of the cocktail lounge had arrived, and drinkers in Detroit were again free to enjoy the many entertainment destinations Detroit had to offer.

While this book focuses primarily on early Detroit and its drinking establishments, and while it cannot include or describe every hotel, saloon, bar, cocktail lounge, or restaurant throughout the city's history, I hope it will introduce and familiarize the reader a bit with the Detroit that once had been known as "the city dynamic." Many of the destinations pictured and described here have long since disappeared, but their presence helped shape not only the geography of the city, but its character, culture, and personality. We should not forget that the 19th-century world recognized this city not just as a manufacturing giant but as a travel destination highly prized and considered distinctive for its hospitality, culture, and entertainment. One can only hope that continued glimpses of early Detroit will encourage residents to embrace their city's illustrious past and to preserve it for future generations.

One
DETROIT'S EARLY TAVERNS

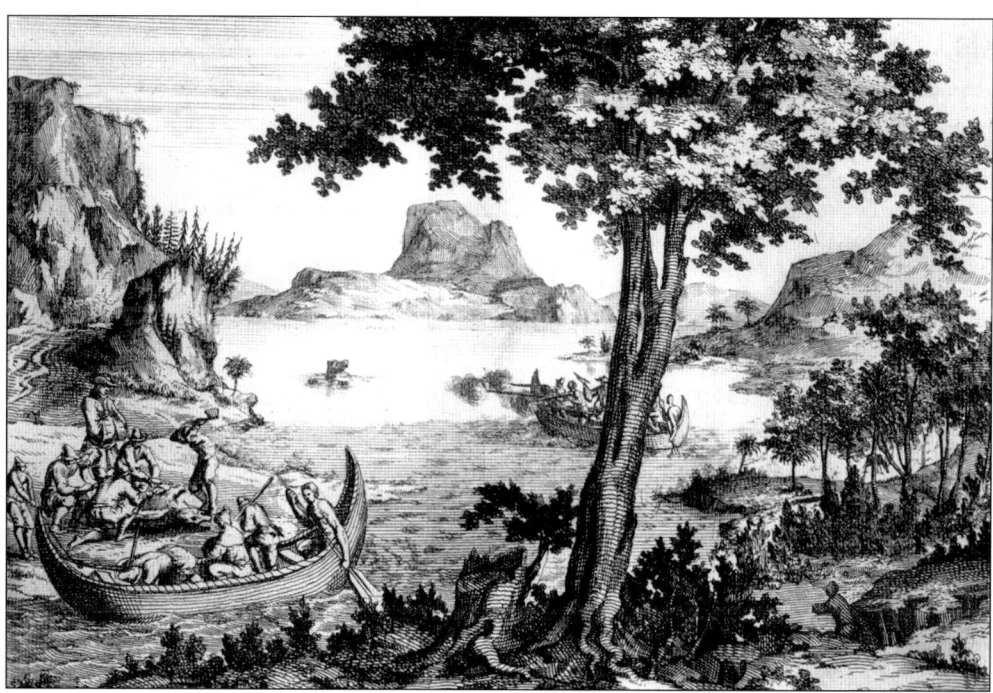

When he sailed up the Detroit River in 1679 with French explorer René-Robert Cavelier, sieur de la Salle, Fr. Louis Hennepin marveled at the beauty and abundant natural resources the region had to offer. Calling it "an earthly paradise of game and hardwood trees," the French recognized that Detroit's proximity to water made it a perfect location for fur trade and an ideal gateway to the country's interior and points west. (Courtesy of the William L. Clements Library, University of Michigan, Ann Arbor.)

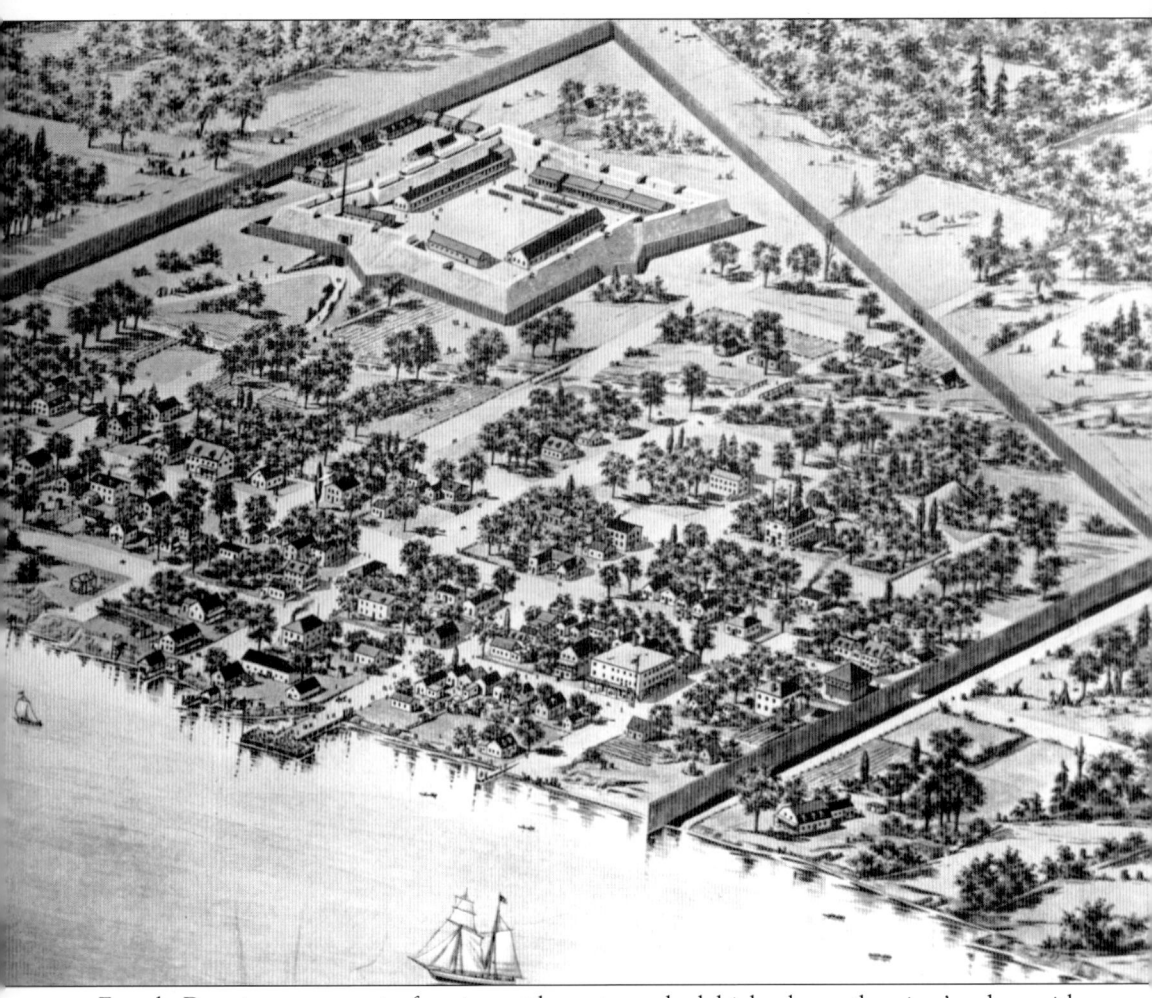

French Detroit was a rustic frontier settlement perched high above the river's edge, with fortification walls surrounding the approximately 70 residences and commercial dwellings. Fort Pontchartrain occupied the area of what is now Washington Boulevard, Griswold, Larned, and Atwater Streets, but the French ribbon farms, situated outside the protection of the fortification, stretched for miles to the east and west. Despite the constant threat of disease and American Indian attacks, early residents took sleigh rides out in the snow for picnics and dined on wine, cheese, and bread. Dressed in the latest European fashions, they also held rollicking dances in their homes that often lasted all night. The hosts of these fetes served elaborate dishes and drank the finest wines and champagnes Paris had to offer. (Courtesy of the Detroit Historical Museum.)

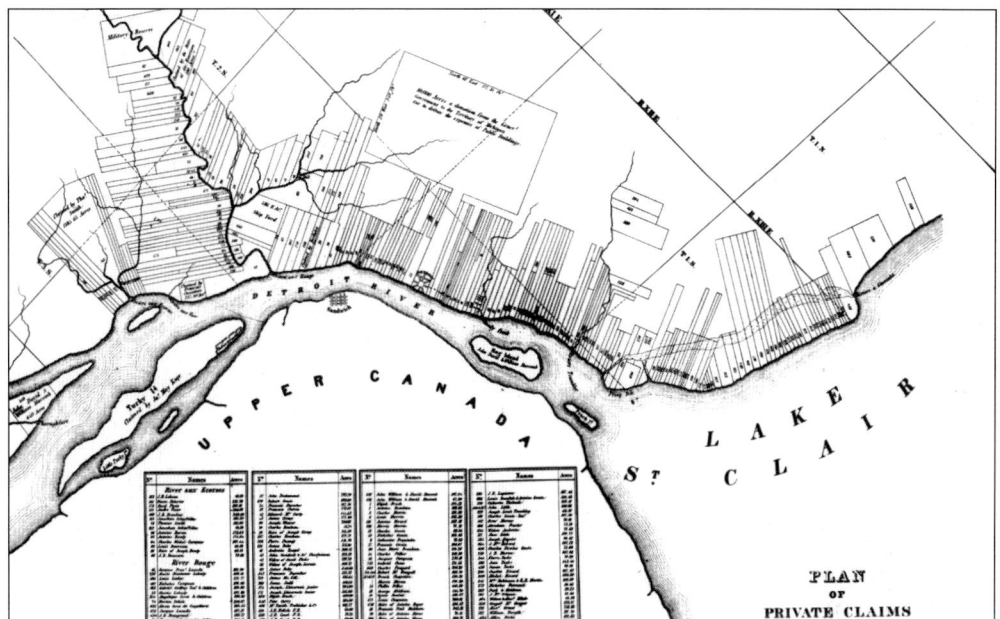

The plan of French Detroit consisted of the early fort and the long, thin strips of land occupied by French farmers that lay outside it. Upon his arrival in 1705, founder Antoine de la Mothe, sieur de Cadillac, gave each French settler a slice of land measuring anywhere from 200 feet to 1,000 feet on the Detroit riverfront and extending back for two to three miles. These farms thus became known as ribbon farms. (Courtesy of the Burton Historical Collection, Detroit Public Library.)

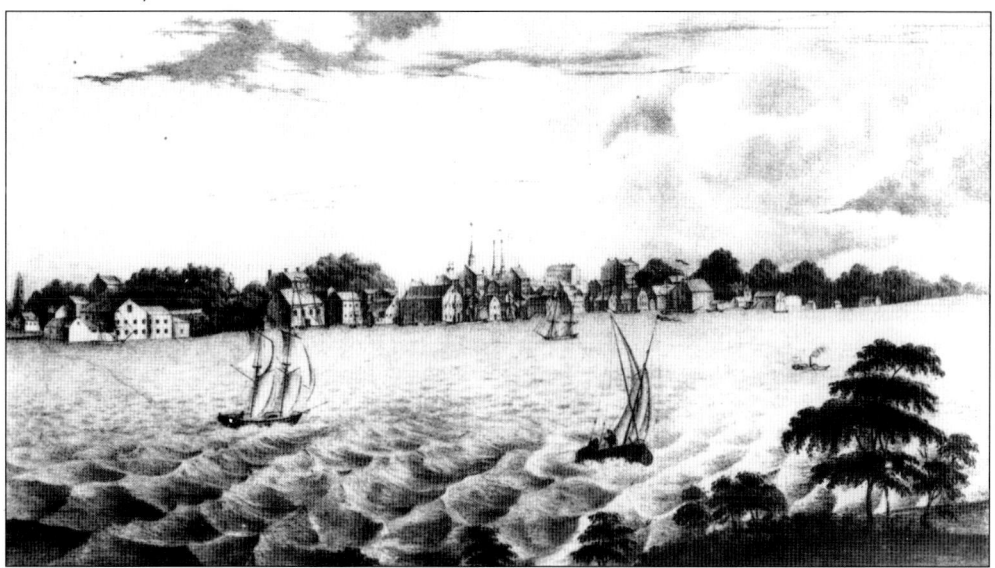

This early drawing illustrates what Detroit's waterfront looked like around 1790. The city's first drinking establishments opened after the British took possession of the city in 1760, in the southeast part of town at Main Street (subsequently renamed Jefferson Avenue after the 1805 fire that destroyed the city) and Randolph Street. Taverns like Forsyth's were run and owned by former military men charged with the impossible task of keeping their patrons sober. (Courtesy of the Detroit Historical Museum.)

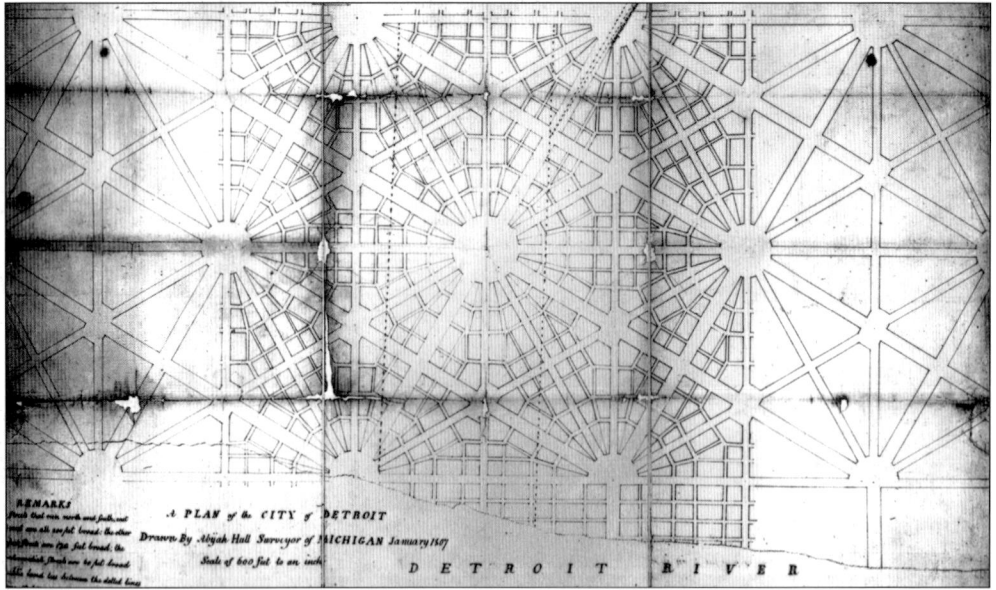

In 1806, noted Detroit politician Judge Augustus B. Woodward reconfigured the city's boulevards and streets into a snowflake design reminiscent of Charles L'Enfant's newly designed plans for Washington, D.C., and Paris. The long, thin French ribbon farms have been replaced by an arrangement of streets resembling the spokes of a wheel, radiating outward from Grand Circus Park. Houses and businesses were located at the river, outside the pinwheel-shaped fort (mid-left). (Courtesy of the Burton Historical Collection, Detroit Public Library.)

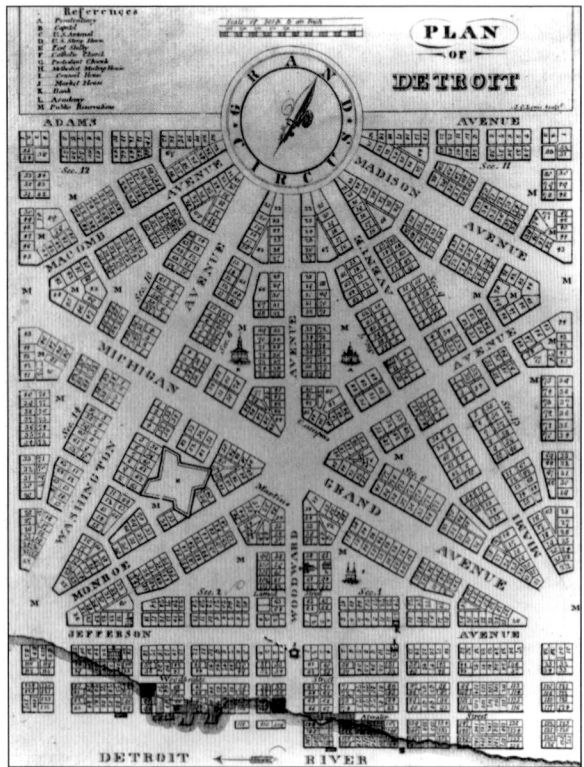

This slightly later plan (around 1810) represents a more developed version of Woodward's plan, with the streets leading from Grand Circus Park more clearly articulated. (Courtesy of the Burton Historical Collection, Detroit Public Library.)

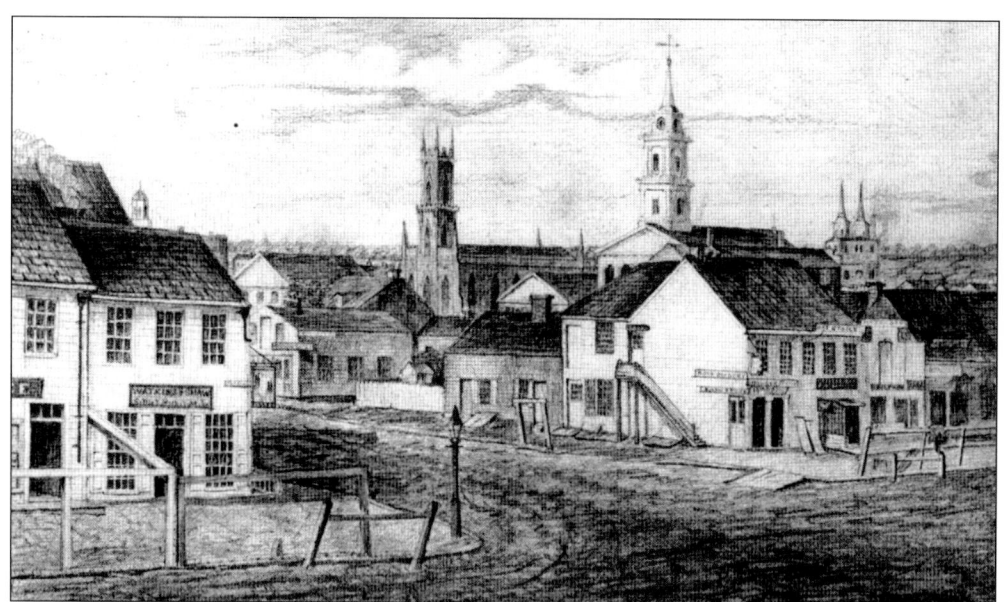

The southwest corner of Jefferson Avenue at Griswold Street has long held a place in Detroit's early history. Antoine de la Mothe, sieur de Cadillac, and Detroit's other early French residents built the settlement's first stockade on the site. Bodies of British officers, killed nearby in an infamous American Indian conflict, called the Battle of Bloody Run, were held in state at the King's Corner, a tavern long occupying this spot. The Shades Tavern, pictured here on the left corner, was open from around 1830 until 1851. (Courtesy of the Burton Historical Collection, Detroit Public Library.)

Bookkeeper John Askwith patronized every tavern in town and was most particular about the drinks he ordered but did not pay for. Milo Quaife writes that Askwith "usually took punch by the bowl and brandy by the glass" but preferred "toddies, eggnogs, bitters, slings, and rum." The unpaid bills Askwith left behind in 1795 identify the measurements used and the beverages sold in Detroit's 18th-century taverns. (Courtesy of the Burton Historical Collection, Detroit Public Library.)

EAGLE TAVERN,
DETROIT.
GOOD ACCOMMODATIONS FOR TRAVELLERS.

RATES AS FOLLOWS:

Boarding by the week,	18s 0d
Ditto by the day with lod'g,	4s 6d
Do. by the meal,	1s 6d
Cold meals,	1s 0d
Span of Horses to hay one night,	3s 0d
One Horse to ditto,	1s 6d
Each cart load of goods drawn for customers,	1s 0d
Lodging,	1s 0d
Good pasture for cattle,	
One yoke of cattle per night,	2s 0d

JAMES BUSBY.

Public houses like the Eagle Tavern provided "good accommodations" for residents, travelers, and whatever animals they brought with them. To obtain a liquor license, the proprietor had to show proof of at least two beds for overnight guests. Guests sat together at one long table for meals, feasting on whatever game, fruits, and vegetables were in season. Winter months limited the availability of certain foods but not alcohol; tavern menus offered everything from cider and wines to brandies, liqueurs, and malt whiskey. Eagle Tavern owner James Busby still lists prices in English currency; boarding by the week costs 18 shillings. (Courtesy of the Detroit Historical Museum.)

As early as 1812, Detroit had already transformed from a wilderness outpost to a bustling town, with commercial buildings and some boat traffic. Residents now had a fair number of taverns and public houses to choose from along the river, which remained a source of both economic prosperity and entertainment for residents and visitors alike. In this 1862 photograph, onlookers gather under umbrellas to watch freighters and steamships make their way toward Belle Isle. Tavern fare included French dishes such as frog legs and lake perch, in addition to chops and steaks prepared in the English tradition. Public houses offered ground-floor bars for men and second-floor restaurants for ladies—a segregation of the sexes in Detroit's drinking establishments that would continue until Prohibition. (Courtesy of the Burton Historical Collection, Detroit Public Library.)

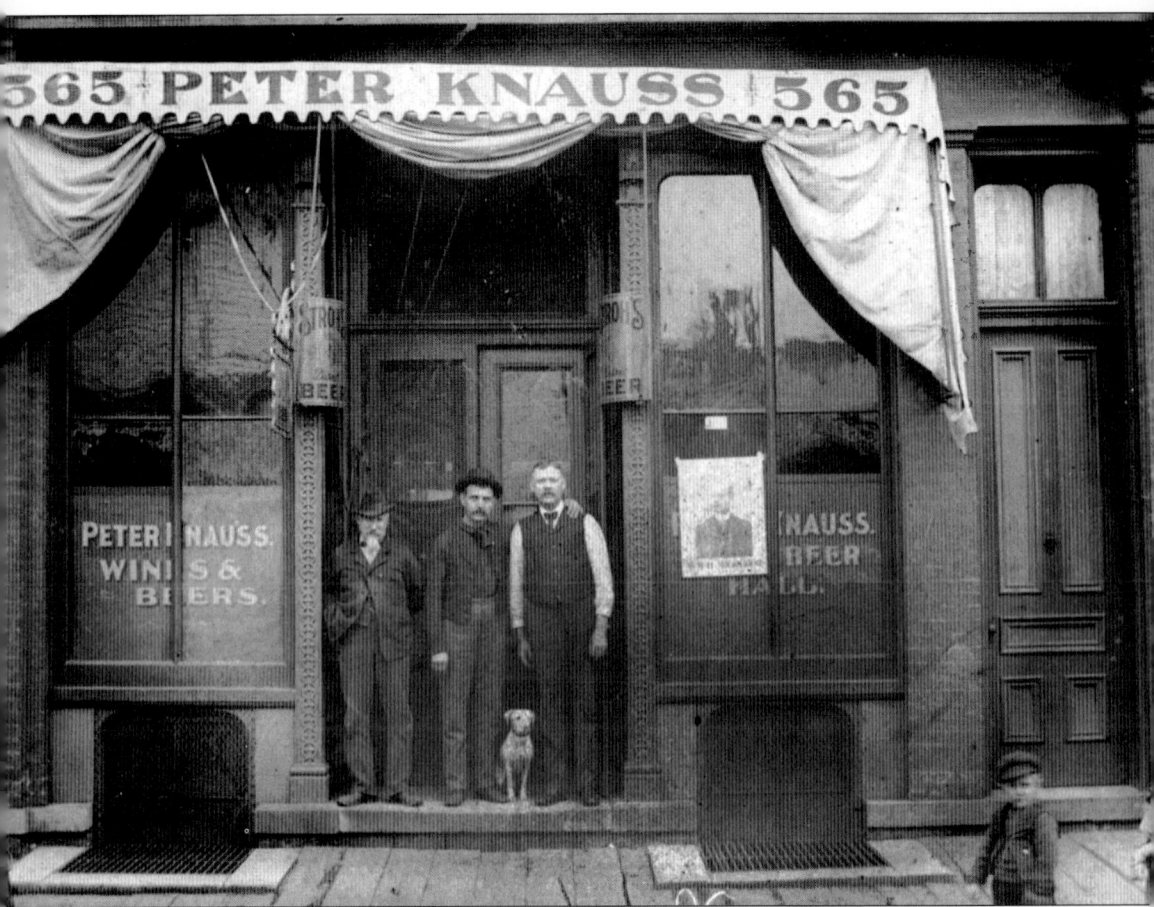
Peter Knauss ran a tavern for workingmen in the city. The signs on either side of the entrance to his establishment say that he sold beer and wines to take home but served only Stroh's lager in his beer hall. (Courtesy of the Burton Historical Collection, Detroit Public Library.)

Two

From Frontier Town to Travel Destination

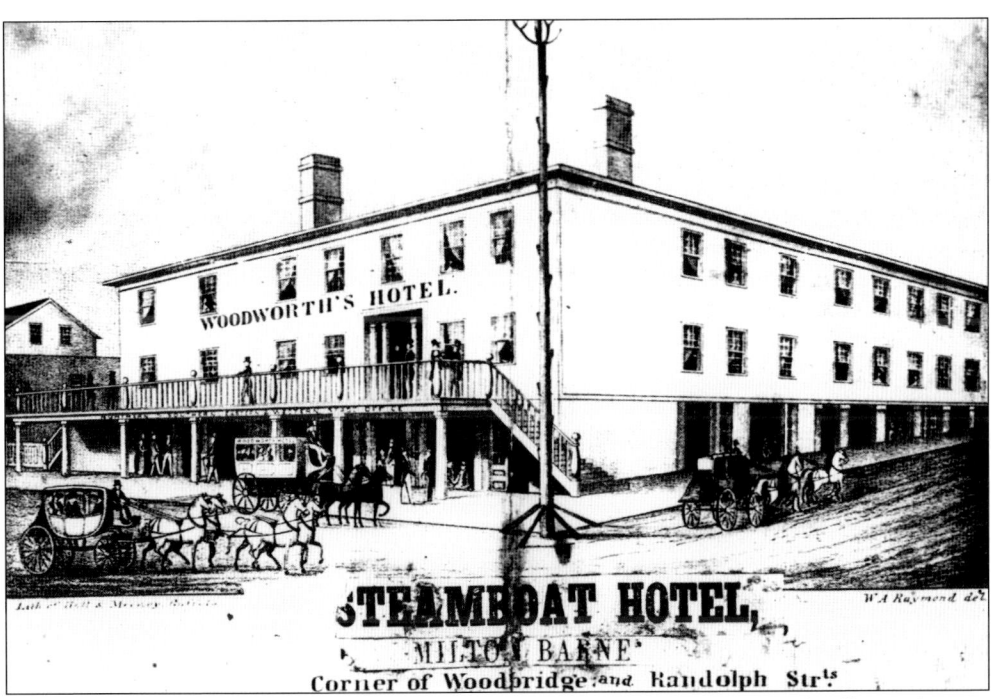

Detroit's earliest hotel operated on the southwest corner of Wayne Street and Jefferson Avenue long before the fire of 1805, but the city's most famous accommodations belonged to the wealthy and influential Ben Woodworth. Located in the city's original business district at Jefferson Avenue and Woodbridge Street, his Steamboat Hotel sat at the foot of the city's primary ferry dock, open just in time to welcome the first steamboat passengers to arrive in Detroit in 1818. (Courtesy of the Burton Historical Collection, Detroit Public Library.)

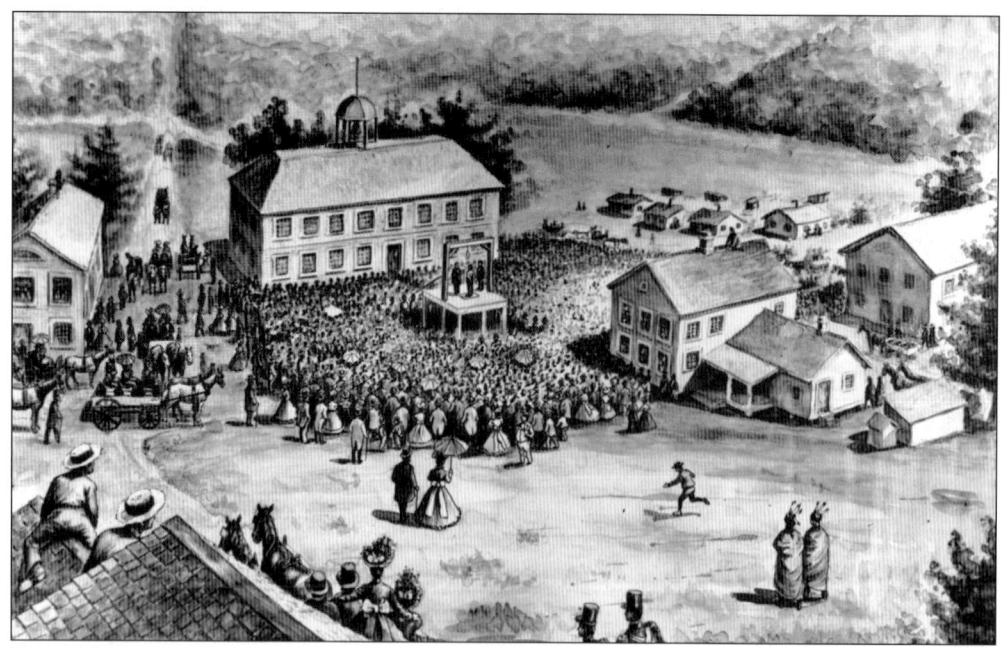

During his tenure in Detroit, residents charged Ben Woodworth with a number of important civic duties that included overseeing two public hangings in 1821. For the second of these, Woodworth erected a gallows in front of the hotel and hired a regiment band to play for the occasion. (Courtesy of the Burton Historical Collection, Detroit Public Library.)

By 1825, patrons had begun to tire of the overcrowded conditions at the Steamboat Hotel and booked rooms at places like the elegant Mansion House instead. The Steamboat remained open through the 1840s, but Woodbridge Street and Jefferson Avenue became less prominent as an entertainment destination. Ben Woodworth sold his Detroit properties and retired to St. Clair, where he died in 1874 at the age of 91. (Courtesy of the Burton Historical Collection, Detroit Public Library.)

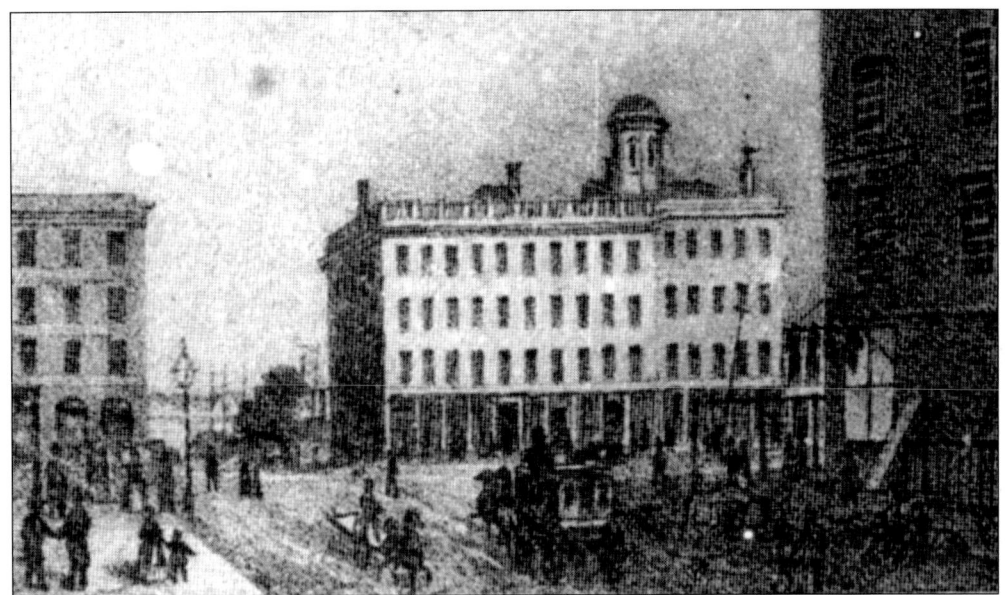

The Michigan Exchange, located farther down on the southwest corner of Jefferson Avenue and Shelby Street, was built with funds provided by wealthy Detroit businessman Shubael Conant. The Michigan Exchange opened in 1835 and enjoyed popularity as a travel destination until 1892, when it was demolished. The proprietor of Hawley's Cleveland Beer Room, located under the Michigan Exchange on the Shelby corner, would later own one of Detroit's earliest breweries. (Courtesy of the Walter P. Reuther Library, Wayne State University.)

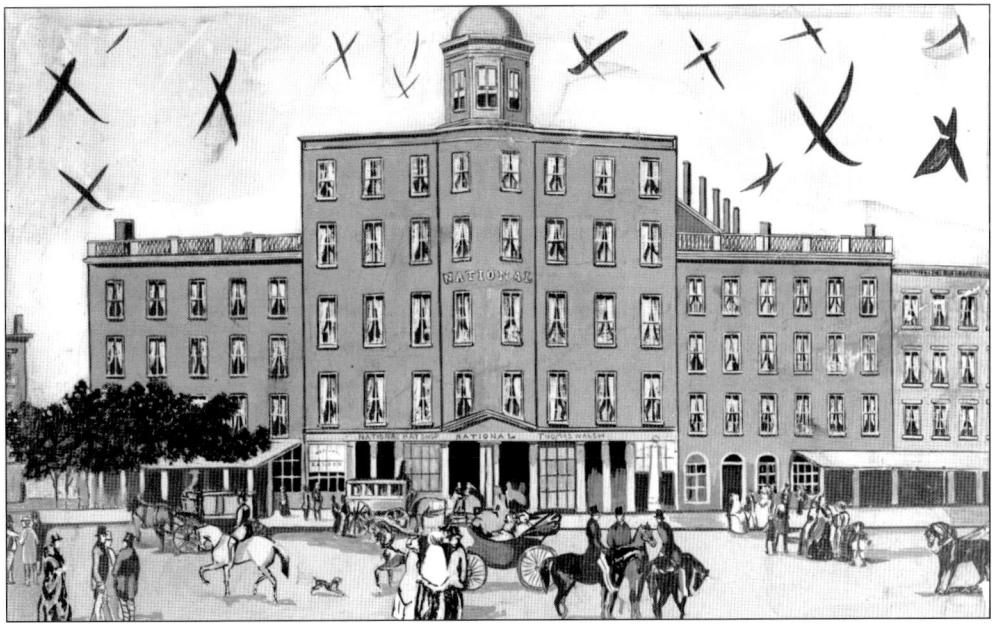

The National Hotel opened at the corner of Woodward and Michigan Avenues on the Campus Martius in 1836. Every year, the National hosted the Volunteer Firemen's Ball, the quintessential social event of early American Detroit. The National occupied perhaps the most auspicious hotel location in Detroit's history—home of the famous Russell House in 1857 and, in 1907, the Pontchartrain Hotel. (Courtesy of the Walter P. Reuther Library, Wayne State University.)

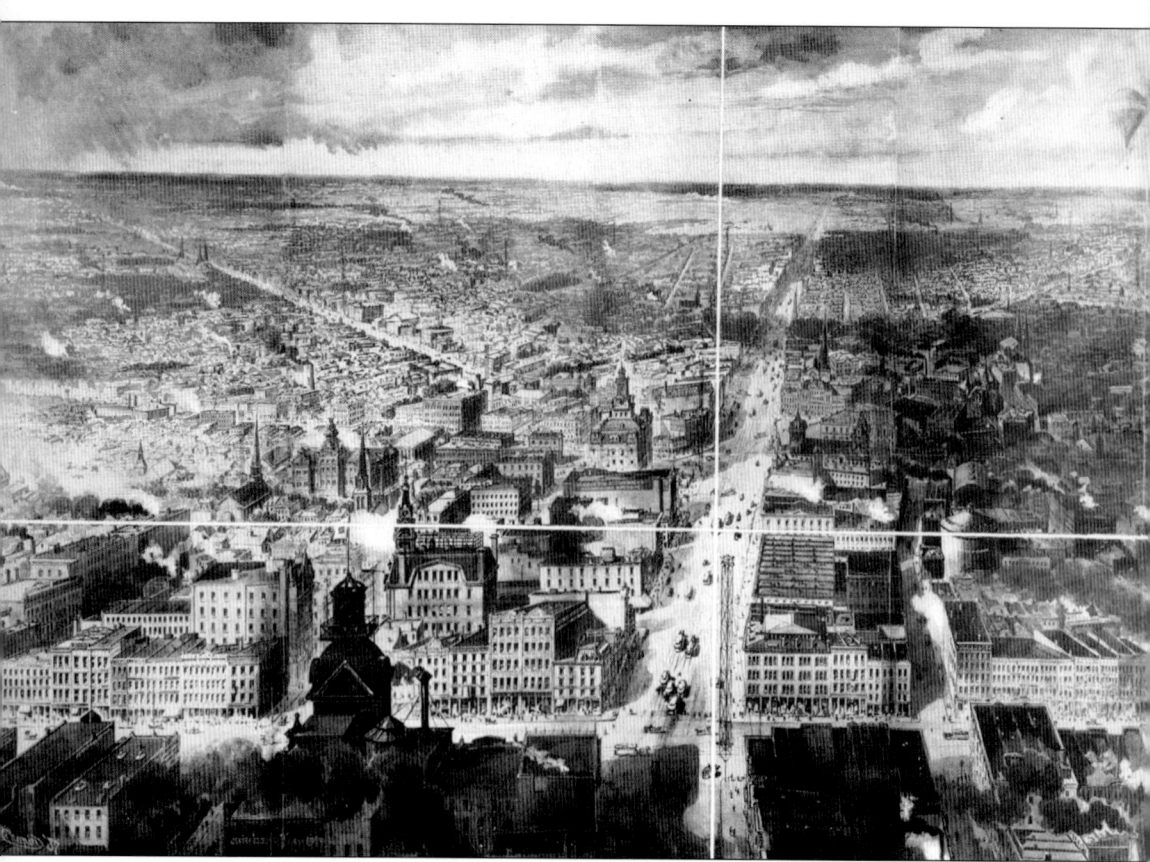

Early taverns and public houses had few visitors and functioned on an almost purely civic level, but their focus shifted once steamboat travel commenced in 1818. By 1837, Detroit had grown into a popular but overcrowded travel destination for people anxious to glimpse the western territory. That year, English native Harriet Martineau wrote to a friend that the accommodations in Detroit seemed insufficient to handle the influx of visitors. She enjoyed her stay at the "new American" at Jefferson Avenue and Randolph Street, but the hotel was overbooked: "We had to wait until near one o'clock before any of us could have a room in which to dress." On the right side of the drawing, a balloon floats over the city's congested streets. (Courtesy of the Walter P. Reuther Library, Wayne State University.)

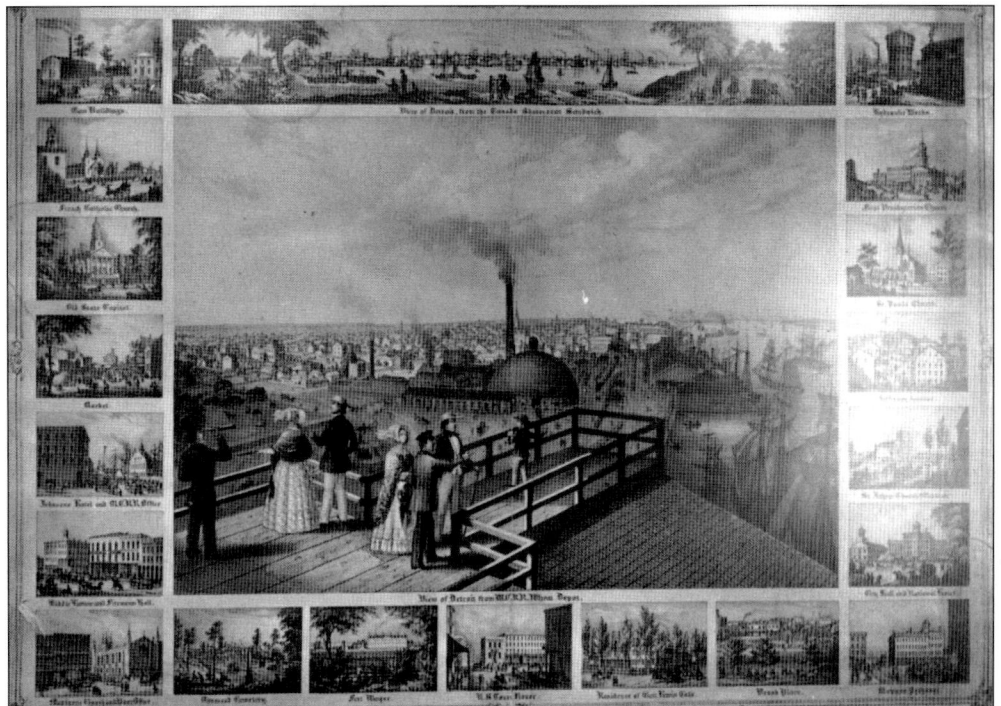

This advertisement from the late 1840s or early 1850s depicts well-dressed visitors taking in Detroit's waterfront from a rooftop vantage point. The railroad yard of the Michigan Central Railroad appears in the center, smoke belching from the chimney of its roundhouse. Vignettes highlighting the city's main tourist attractions, including the National Hotel, form the advertisement's border. (Courtesy of the Detroit Historical Museum.)

This photograph presents an identical view of Detroit's riverfront and the Michigan Central railroad yard. Train routes began running to and from Detroit by the late 1840s. (Courtesy of the Detroit Historical Museum.)

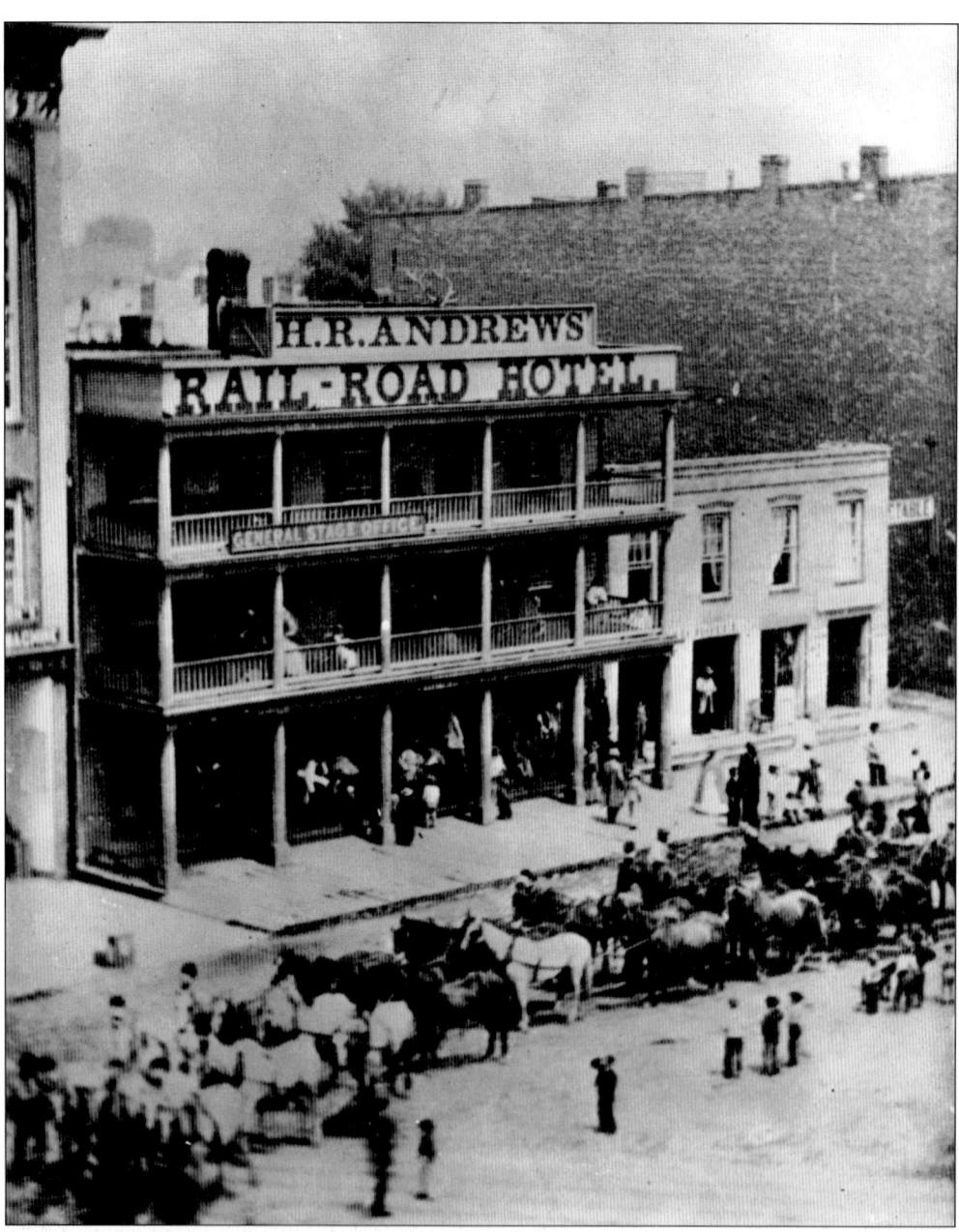

The H. R. Andrews Rail-Road Hotel, located on the northeast side of the Campus Martius at the site of the present-day Detroit Opera House, opened in 1838. The hotel's first visitors had to endure the sights and smells of a nearby stockyard until the proprietor's complaints forced the latter's removal to Griswold Street and Grand River Avenue. The Rail-Road Hotel was located in what would soon become the heart of Detroit, and residents and visitors to the hotel witnessed important historical events such as the departure of Michigan troops for the Civil War and a parade in honor of the late president Abraham Lincoln. During the late 1830s, the Rail-Road Hotel served as the hub for stagecoach travel, which explains the considerable line of horses and coaches waiting out front in this photograph. (Courtesy of the Burton Historical Collection, Detroit Public Library.)

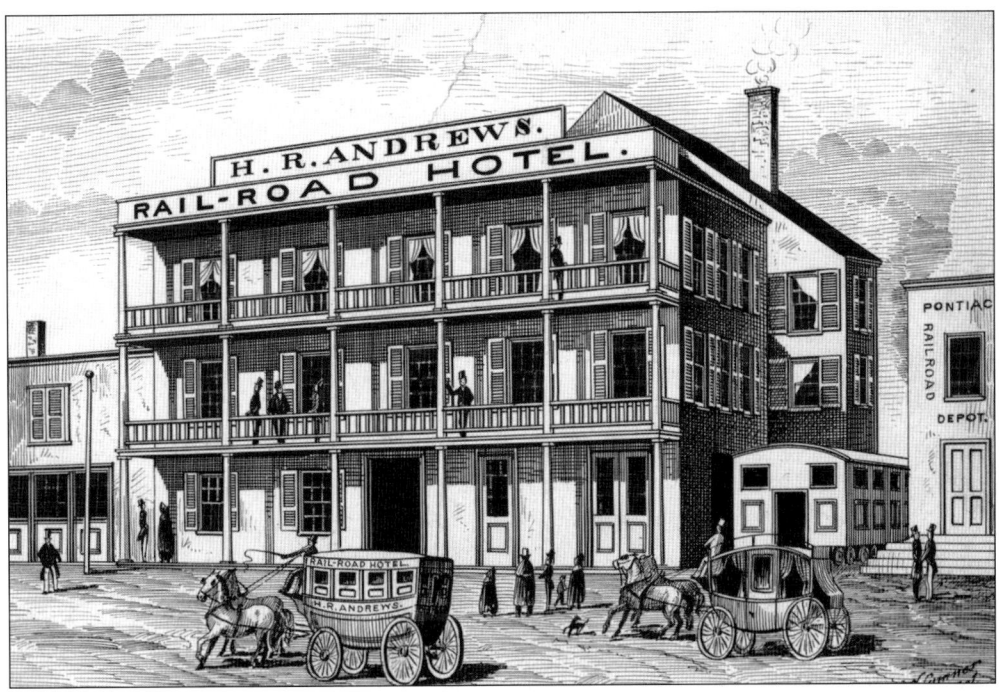

This drawing of the H. R. Andrews Rail-Road Hotel illustrates that it had the three-storied, open balcony arrangement commonly used in Detroit hotel architecture during the early years of the 19th century. In order to enhance its position as a key departure location for one of Detroit's stagecoach lines and to maximize business with rail and steamboat passengers, the hotel provided room, a day's board, and transportation to the hotel from the riverfront for 25¢. The drivers hired by the hotel tended to be a motley crew who often preyed on innocent travelers. (Courtesy of the Burton Historical Collection, Detroit Public Library.)

GRAND OPENING NEW CASINO THEATRE, H. N. Williams, Propr. | E. W. Cobb, Manager. | **MONDAY, OCT. 24.**

Iron Balconies, Ladders and Fire Escapes, on all sides.

WM. W. ANTISDEL, PROPRIETOR, DETROIT, MICH.

DINNER.

SOUP.
Macaroni.

FISH.
Baked White, Butter Sauce.

BOILED.
Sugar Cured Ham. Leg of Mutton, Caper Sauce.

ROAST.
Sirloin of Beef with brown Gravy. Ribs of Beef with Brown Potatoes.
Loin of Pork, Apple Sauce. Lamb, Mint Sauce.
Beef Heart with Dressing.

ENTREES.
Fresh Stewed Beef with Potatoes.
Parsnip Fritters, Brandy Sauce.

RELISHES.
Worcestershire Sauce. Halford Sauce. French Mustard. Pickled Beets.
Tomato Catsup. Salad Dressing. Olive Oil.

COLD.
Corned Beef. Ham. Lobster Salad. Mutton.

VEGETABLES.
Boiled Potatoes. Mashed Potatoes. Cauliflower. Spinach.
Stewed Carrots.

PASTRY.
Green Apple Pie. Grape Tart Pie. Pumpkin Pie
Ice Cream.
Grapes. Apples.

Tea. Milk. Coffee.

WEDNESDAY, OCTOBER 26, 1887.

NEW CASINO THEATRE. | Fenwick Armstrong Co. IN THE **New Monte Cristo,** Prices, 10, 20 & 30c.

Detroit's first theatrical performances were most likely held in the Steamboat Hotel barn during the 1830s. Thereafter, theaters opened inside hotels or public houses like the New Casino Theatre at the Antisdel House, which played host to many distinguished actors. The property's original owner, Mary Watson Hudson, bought it for the staggering sum of 1¢ in 1806. Proprietor Antisdel's advertisement, which mentions fireproof brick and a sturdy fire escape, reveals that fear of fire still gripped Detroit residents and business owners. The devastation caused by the fire of 1805, and other subsequent blazes, remained fresh in the city's 19th-century consciousness. (Courtesy of the Burton Historical Collection, Detroit Public Library.)

Named for former mayor and distinguished citizen John Biddle, this hotel opened in 1851 on Jefferson Avenue and Randolph Street on the historic site of the Hull residence and the former American Hotel. The most notable architectural elements of the Biddle House were its distinctive cupola, from which an American flag always flew, and the balcony over the front portico. Typically, noted guests such as Andrew Johnson and Ulysses S. Grant used this platform to address crowds gathered in the street below. (Courtesy of the Burton Historical Collection, Detroit Public Library.)

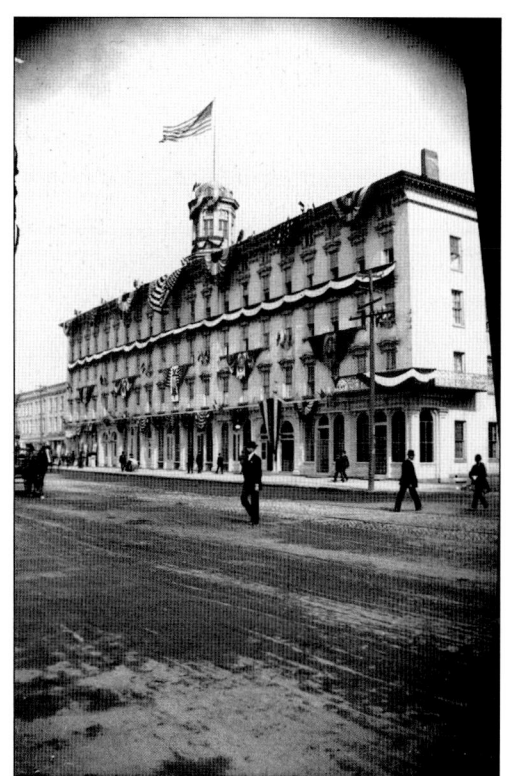

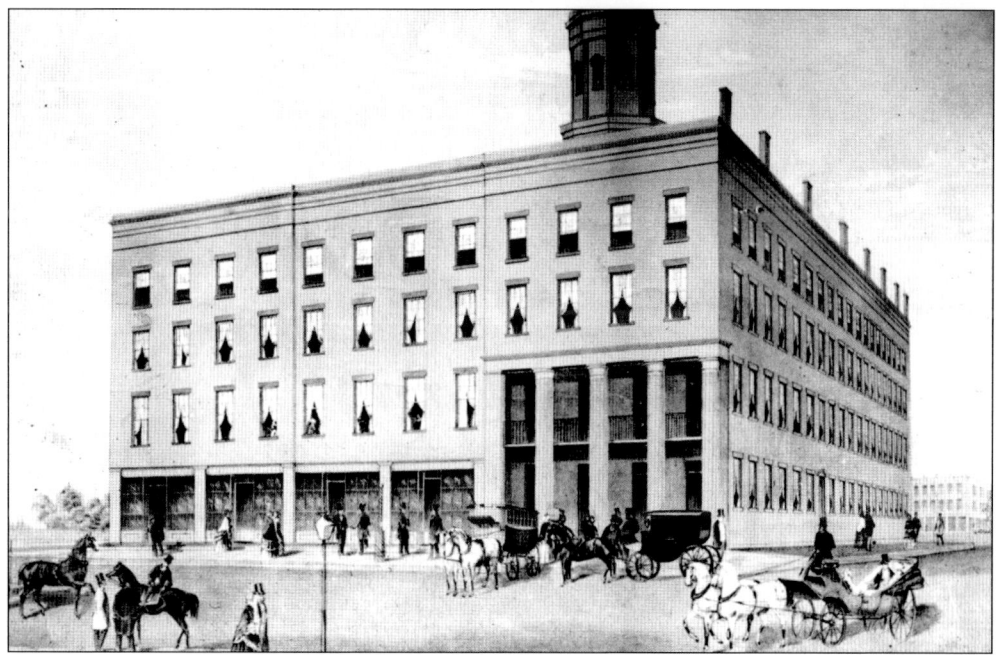

During its tenure as the most popular travel destination on Detroit's waterfront, the Biddle House appeared in many newspapers, advertisements, and brochures during the 1850s. This one depicts the hotel as a graceful building on a bustling commercial street. (Courtesy of the Burton Historical Collection, Detroit Public Library.)

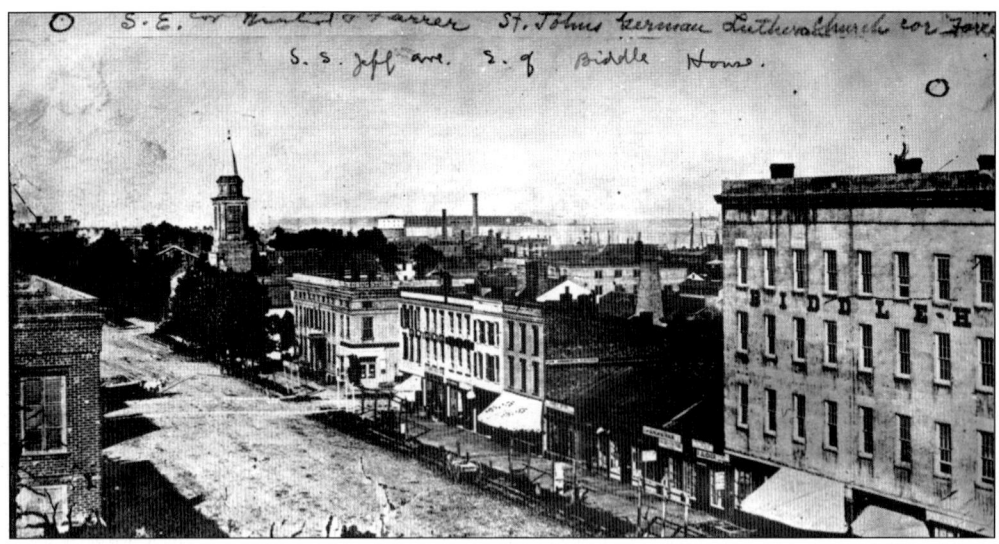

The photograph above shows Detroit's burgeoning business district in the 1850s. The Biddle House, on the southeast corner of Jefferson Avenue, is visible in the right-hand corner. The smokestacks of the Michigan Central Railroad appear in the distance on the waterfront, and the spire of St. John's German Lutheran Church protrudes in the photograph's upper left-hand corner. (Courtesy of the Burton Historical Collection, Detroit Public Library.)

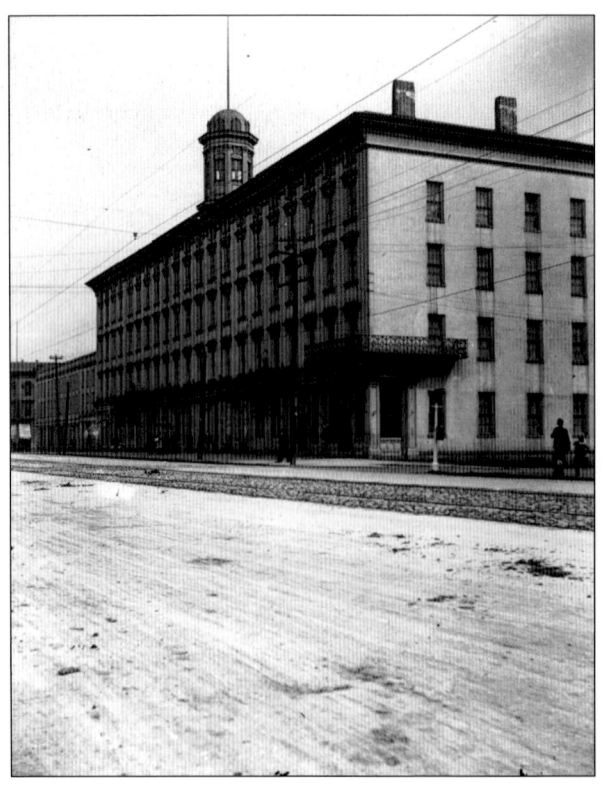

After the 1848 fire that burned most of the area between East Jefferson Avenue and the Detroit River, city planners opened the Biddle House in an attempt to reestablish East Jefferson as the city's chief business thoroughfare. They hoped that the attractive new hotel, illuminated by Detroit's new gaslights, would attract visitors to the area, but their efforts proved futile. The city's entertainment and business focus had already shifted north of Jefferson to Woodward Avenue at the Campus Martius. (Courtesy of the Burton Historical Collection, Detroit Public Library.)

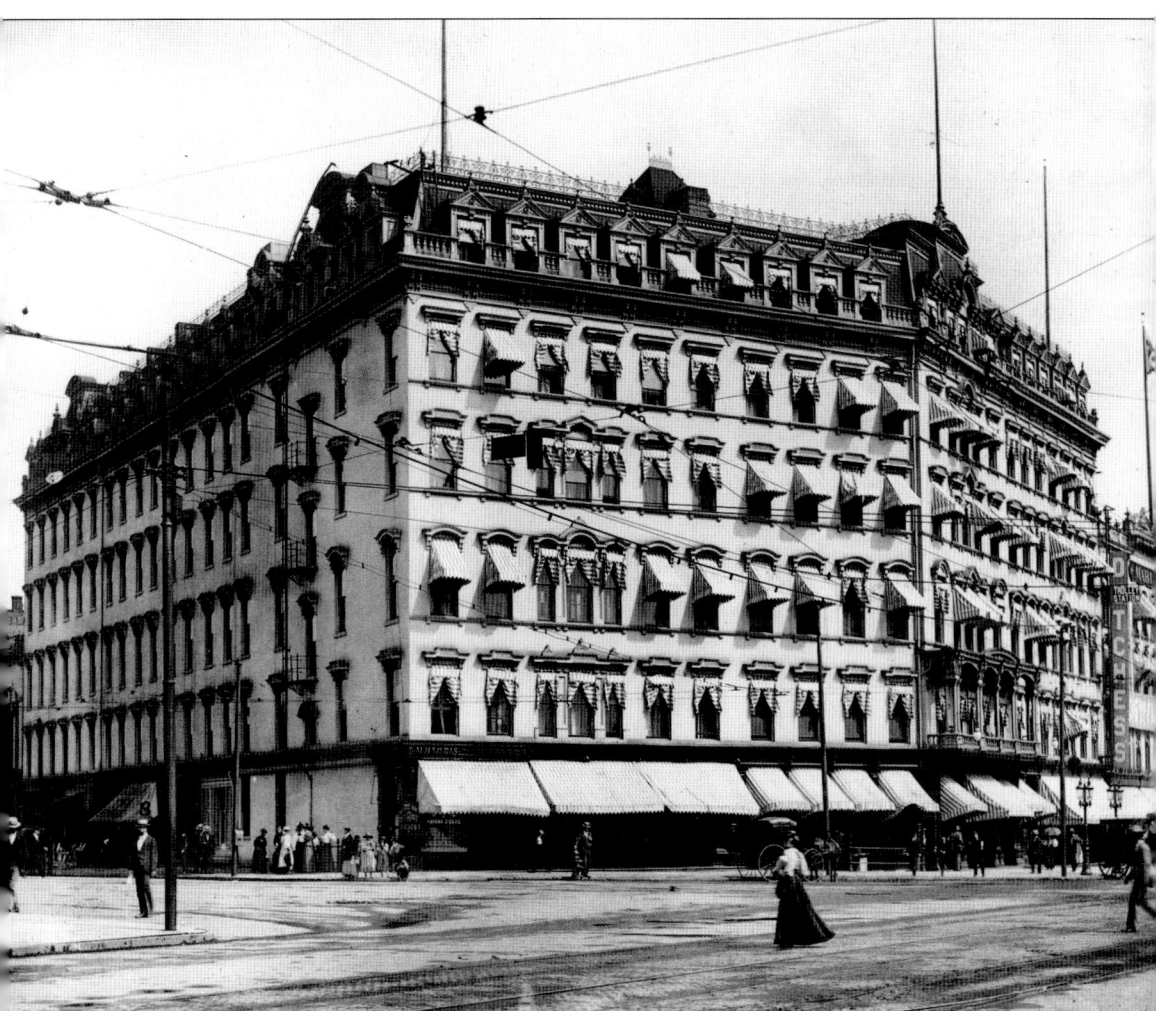

With the opening of Detroit's famed Russell House on September 28, 1857, the Campus Martius (from the Latin meaning "field of Mars") became Detroit's official entertainment and business center. The advertisements of the day marvel at the cost of a stay at the Russell; the hotel reputedly charged an outrageous $2.50 a day. By 1862, local newspapers called it "the biggest hotel in Michigan" and "the very best in the Northwest." Like the Steamboat Hotel and the H. R. Andrews Rail-Road Hotel, the Russell House served as the setting for many important political events, such as a rally led by the abolitionist John Brown. (Courtesy of the Burton Historical Collection, Detroit Public Library.)

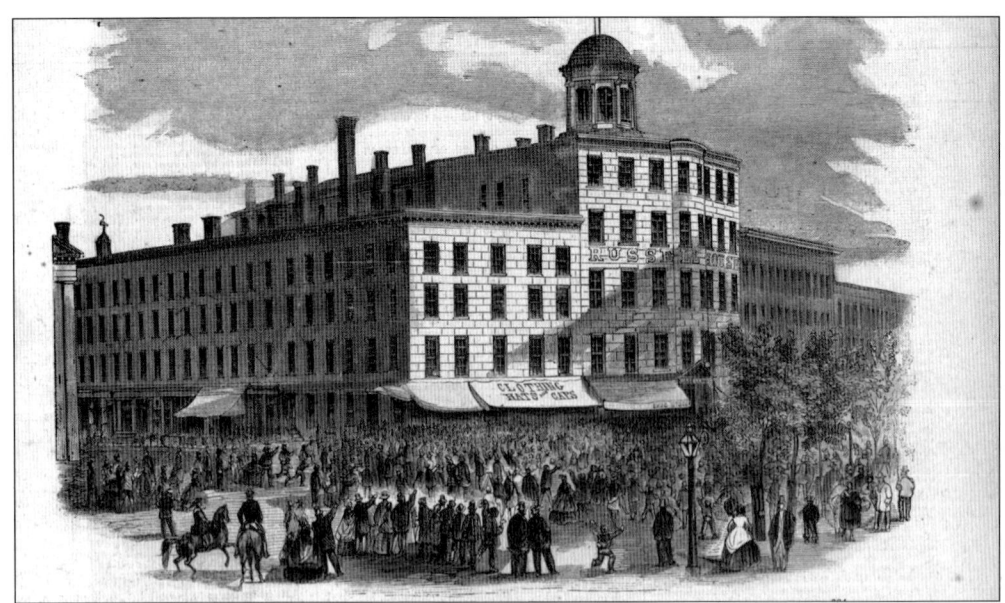

Famed illustrator Frank Leslie penned this interpretation of the exterior of the Russell House in the 1850s. While illustrating the commanding position the Russell House held on the Campus Martius during those years, the illustration also presents a less-idealized view of Detroit's urban landscape. As early as the mid-19th century, American cities had become cluttered by conveniences introduced during the Industrial Revolution, such as light posts, telegraph wires, and storage facilities. (Courtesy of the Walter P. Reuther Library, Wayne State University.)

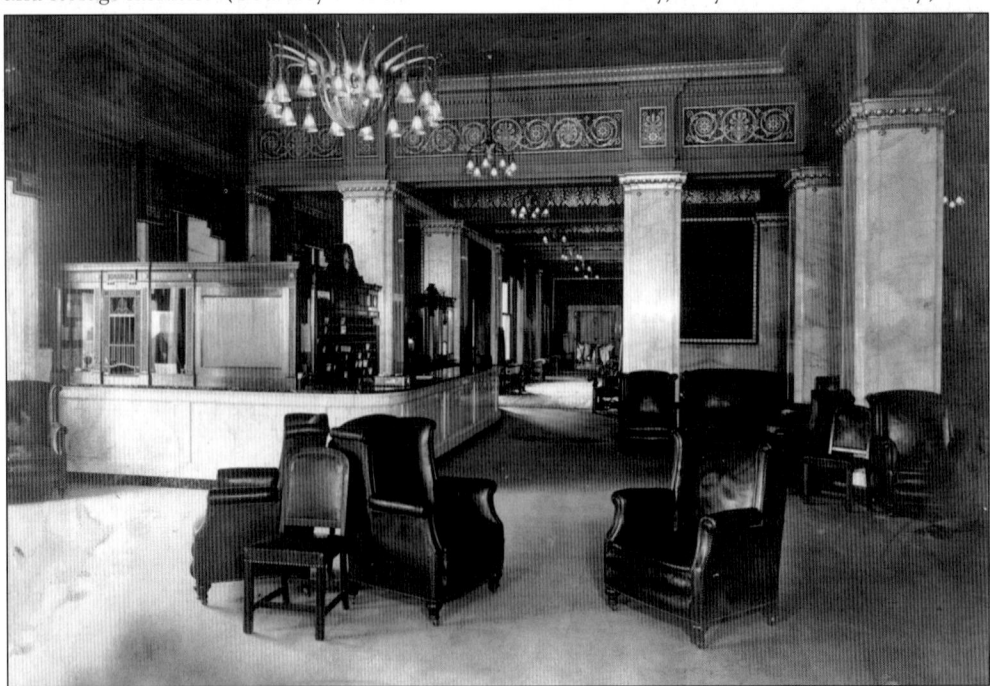

The year after its opening, the Russell House played host to the celebration honoring Detroit's 157th year. A number of elaborate balls and suppers to mark the event were held in its elegant interior. (Courtesy of the Burton Historical Collection, Detroit Public Library.)

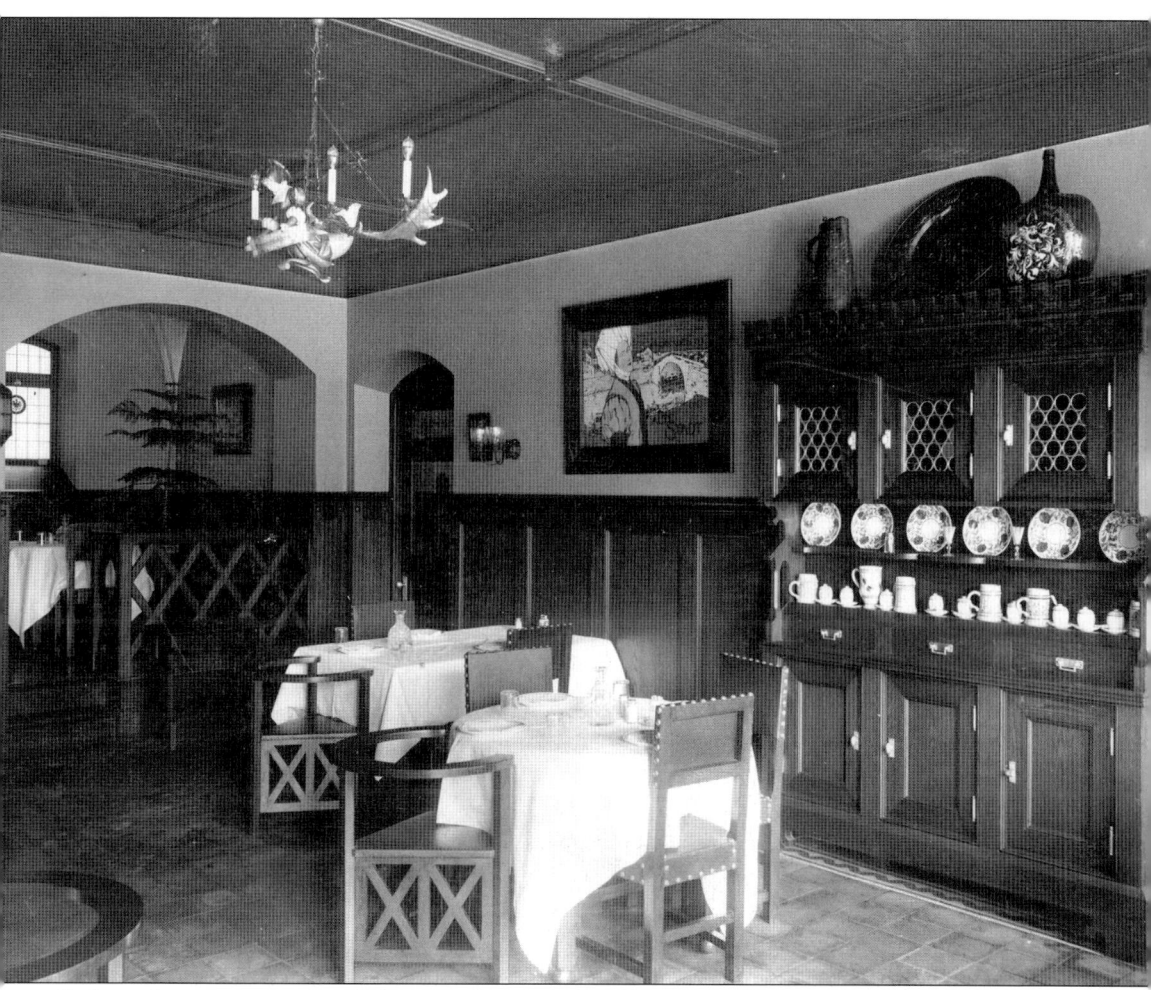

Only male guests patronized the Russell House bar, but men and women dined together in its elegant café, where expensive carpets and white tablecloths combined both masculine and feminine decorative elements. The antler chandeliers suspended from the ceiling derive from the more casual and decidedly more masculine saloon interiors of the day. (Courtesy of the Detroit Historical Museum.)

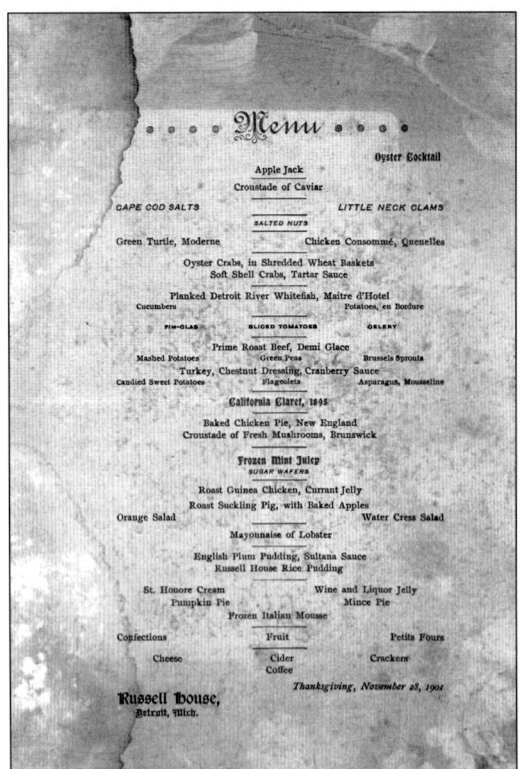

Detroit's distinguished hotel destinations spared no expense when it came to serving their customers. In addition to local delicacies like lake perch, frog legs, and dishes prepared with Michigan fruits and vegetables, Detroit's fine hotels offered fish, game, wines, and cigars imported from the East Coast. This attention to detail included the printing of menus—elaborate four-color masterpieces produced for each meal every day of the year. Menus issued for special business events or for holidays like Thanksgiving were particularly spectacular. (Courtesy of the Detroit Historical Museum.)

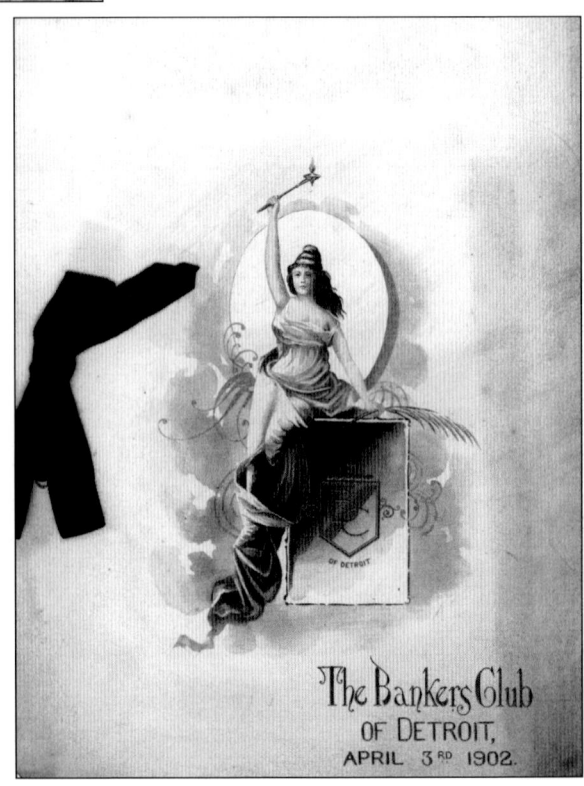

The Detroit Bankers Club enjoyed early-spring delicacies at the Russell House during April 1902. (Courtesy of the Detroit Historical Museum.)

Other hotels, including the Addison, followed the lead established by the Russell House and issued their own daily menus. This elaborate four-color Christmas dinner menu would have been an elegant keepsake for a hotel guest in any era. (Courtesy of the Detroit Historical Museum.)

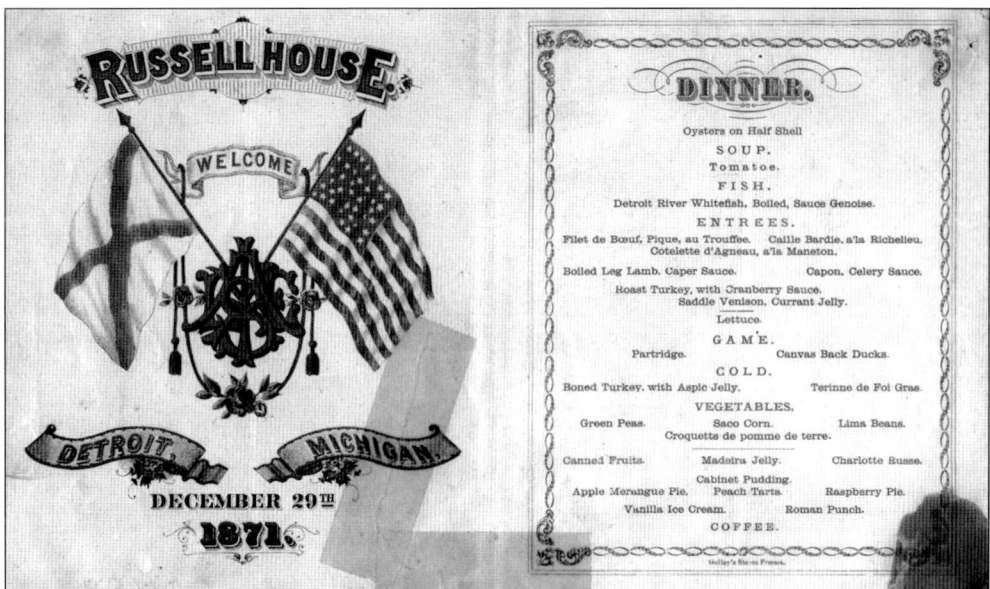

Holidays like New Year's Eve called for especially elaborate menus at the Russell House. Saltwater delicacies like Cape Cod salts and little-necked clams arrived in special refrigerated railcars for the occasion. The dinner menus presented to each patron also included music selected specifically for that evening and played by the hotel's in-house orchestra. Diners could still order applejack, a kind of alcoholic cider drink dating back to 18th-century French Detroit. (Courtesy of the Detroit Historical Museum.)

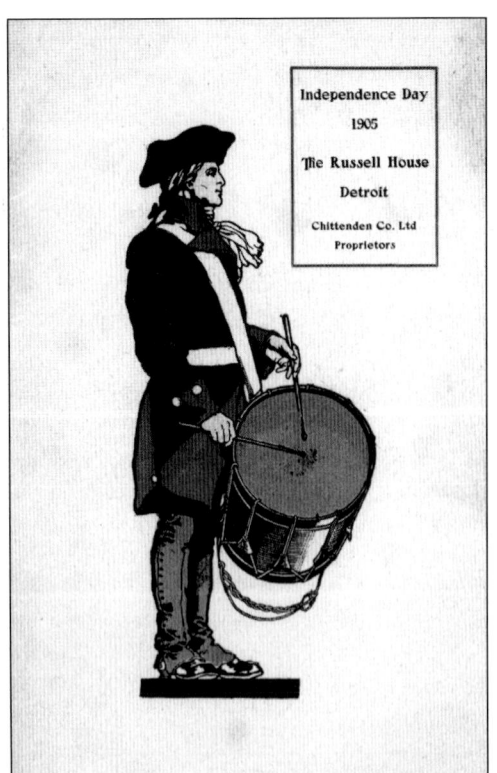

Independence Day dinner at the Russell House in 1902 would have been well attended by residents and guests alike. Undoubtedly, this elegantly designed menu functioned for many years as an excellent keepsake of a memorable evening spent at the Russell. (Courtesy of the Detroit Historical Museum.)

The oppressive heat of the summer months in Detroit would not have deterred residents from attending a Russell House function as grand as the Independence Day celebration, if given the opportunity to do so. (Courtesy of the Detroit Historical Museum.)

The Detroit Opera House had its original home on the Campus Martius beginning in the late 1880s, replacing the Russell House. After the opera house moved in 1905, construction began on the famed Pontchartrain—one of the country's most elegant and technically advanced hotel destinations and birthplace of the automobile industry. (Courtesy of the Walter P. Reuther Library, Wayne State University.)

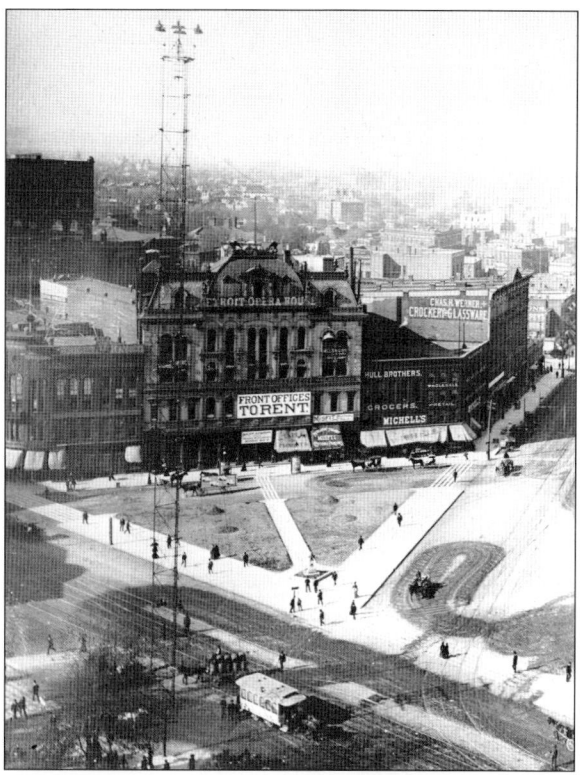

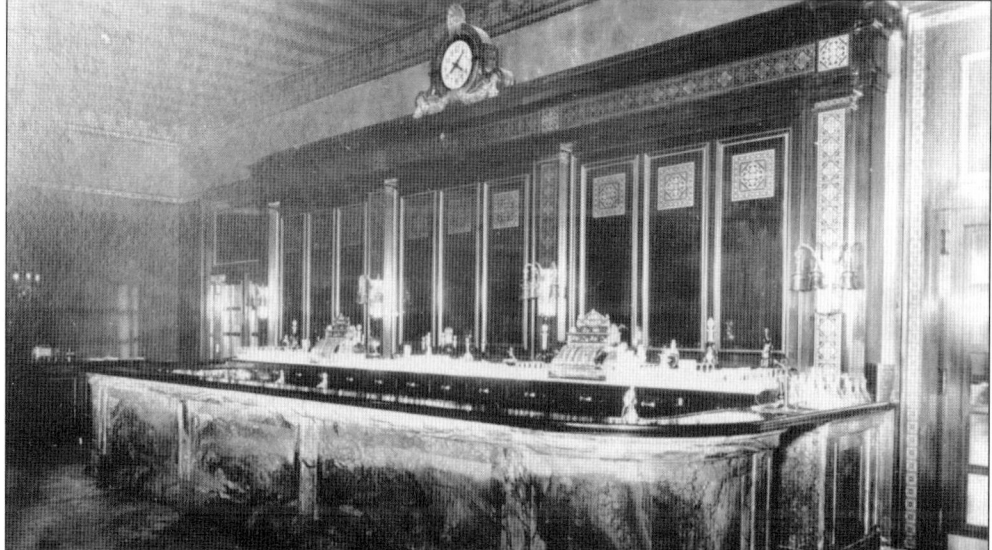

The Pontchartrain taproom became the chosen meeting place of the city's leading businessmen and, most importantly, the birthplace of the automobile industry. Famous teetotalers Henry Ford, R. E. Olds, and Henry M. Leland held court in the hotel's smoke-filled bar, where they exchanged stock tips and ideas. Inventors were often seen carrying their gadgets into the room to demonstrate before automotive royalty. The elegantly appointed taproom was known for its marble bar and the large mirrored wall behind it. (Courtesy of the Burton Historical Collection, Detroit Public Library.)

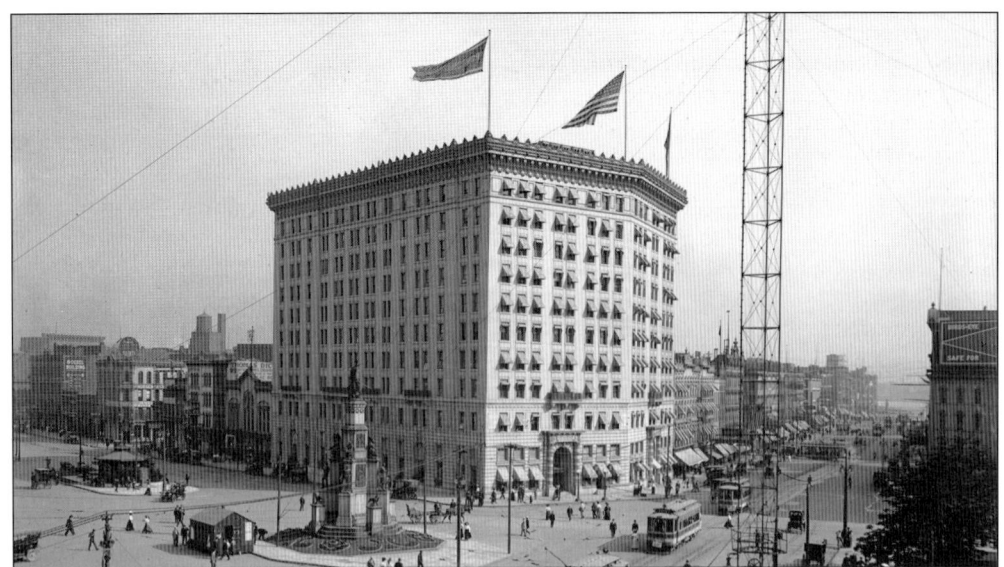

The 1907 Pontchartrain Hotel, original site of the Russell House, replaced the Detroit Opera House in 1907. Designed by noted Detroit architect George D. Mason, the building had no equal with respect to refinement and technological advancement. Carved oak beams and Tiffany stained glass graced its interior, while a sophisticated cooling system kept rare wines, cheeses, and imported cigars at the perfect temperature. (Courtesy of the Walter P. Reuther Library, Wayne State University.)

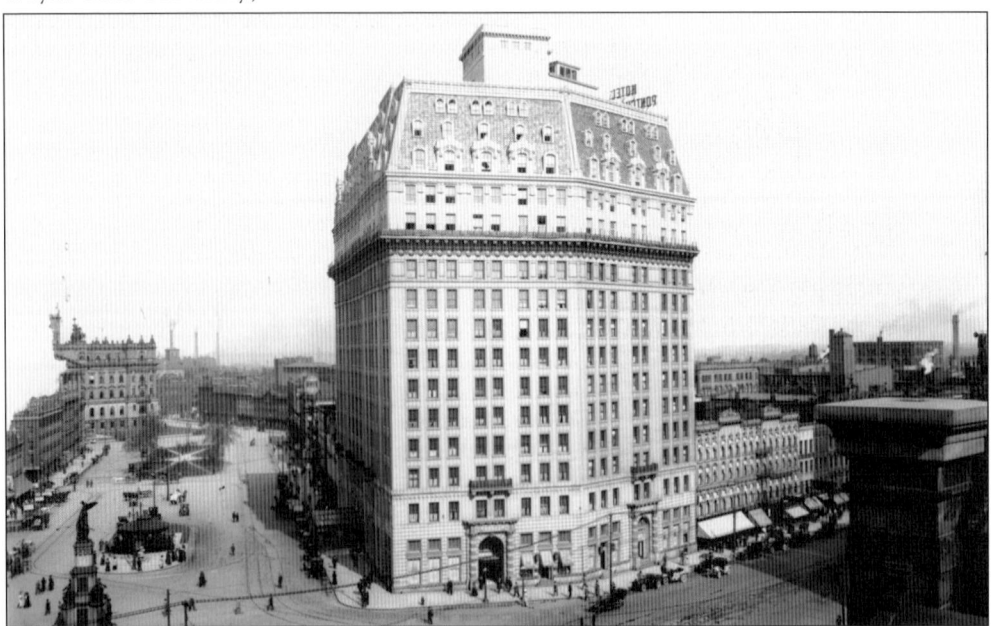

This photograph of the Pontchartrain Hotel was taken around 1915, after five more floors and a mansard room were added to the building in 1913. The architects intended the changes in part to mirror the style of the adjacent city hall, but they also wanted the Pontchartrain to remain competitive with the crop of slick hotels springing up on nearby Washington Boulevard. It was torn down in 1920, when the Detroit Athletic Club usurped it as the city's new gathering place for prominent businessmen. (Courtesy of the Library of Congress.)

For tea at the Pontchartrain, nondrinkers like Henry Ford could order delicacies from a midday menu that contained sweet treats and a variety of teas but no alcohol, except for California claret. (Courtesy of the Detroit Historical Museum.)

Service or Cover Charge 25c

The Pontchartrain
4 O'clock Tea

Afternoon Tea, 50 Cents

| Salted Nuts | Assorted Sandwiches | French Pastry |
| Wine Crackers | Pot of Tea with Cream | Peppermint or Rose Wafers |

TO ORDER—Club Sandwich 50

RELISHES

Celery 25 Ripe Olives 25 Salted Almonds 25

SALADS

Waldorf 60 Blackstone 60 Palm Beach 60 Chicken 1.00
Lobster 1.50 French Endive 50; with Grapefruit 70
Crab Meat 1.00 Grapefruit 60 De Luxe 50
Florida 50 Fruit Salad, Cream Dressing 75 Long Island 60
Golden Gate 60 Pontchartrain, Suprême 1.00

CAKES

Ritz Toast 20 Melba Toast 15 French Pastry 15 Chocolate Eclair 15
Macaroons 20 Lady Fingers 20 Assorted Cakes 25
Pontchartrain Eclair 15 Boston Brown, Raisin or Gluten Bread 15

ICE CREAMS and ICES

Vanilla 30 Chocolate 30 Strawberry 30
Biscuit Tortoni 40 Neapolitan 35 Pontchartrain Parfait 45
Nesselrode Pudding 40 Café or Strawberry Parfait 40
Coupe, Pontchartrain 60 Biscuit Glacé 40
Lemon or Orange Water Ice 25

FRUITS

Grapefruit 25 Fruit Cocktail 50
Sliced Bananas with Cream 25 Sliced Hawaiian Pineapple 30
Preserved Figs 30 Apple 10 Sliced Orange 25

Philadelphia Cream Cheese 20; with Guava Jelly 35

Individual Blackberry, Pineapple or Cherry Preserves 25 Orange Marmalade 25
Grapefruit Marmalade 25

Coffee 20-40-60 Tea 25-40 Cocoa or Chocolate 25-50

2-12-18

The Hotel Pontchartrain
IS A MEMBER OF THE

UNITED STATES FOOD ADMINISTRATION

Eat Plenty--Eat Wisely--But Without Waste

In ordering your food remember that you can assist your government by co-operating in conservation. This is real citizenship.

Food Will Decide the War

SAVE THE WHEAT
SAVE THE MEAT
SAVE THE FATS
SAVE THE SUGAR
SAVE THE FUEL

For

Your Soldiers at the Front Need Them All

The Management must decline to be responsible for damage to outer garments or wraps resulting from accidents of any nature in Dining Room. Maids are in attendance at the door to check and look after them.

World War I food rationing affected every eating establishment in the United States, including Detroit's elegant hotels. The Pontchartrain may have continued to provide the usual delicacies, but this 1914 menu reminds patrons that "food will decide the war" and that eating well without waste will save the soldiers at the front. (Courtesy of the Detroit Historical Museum.)

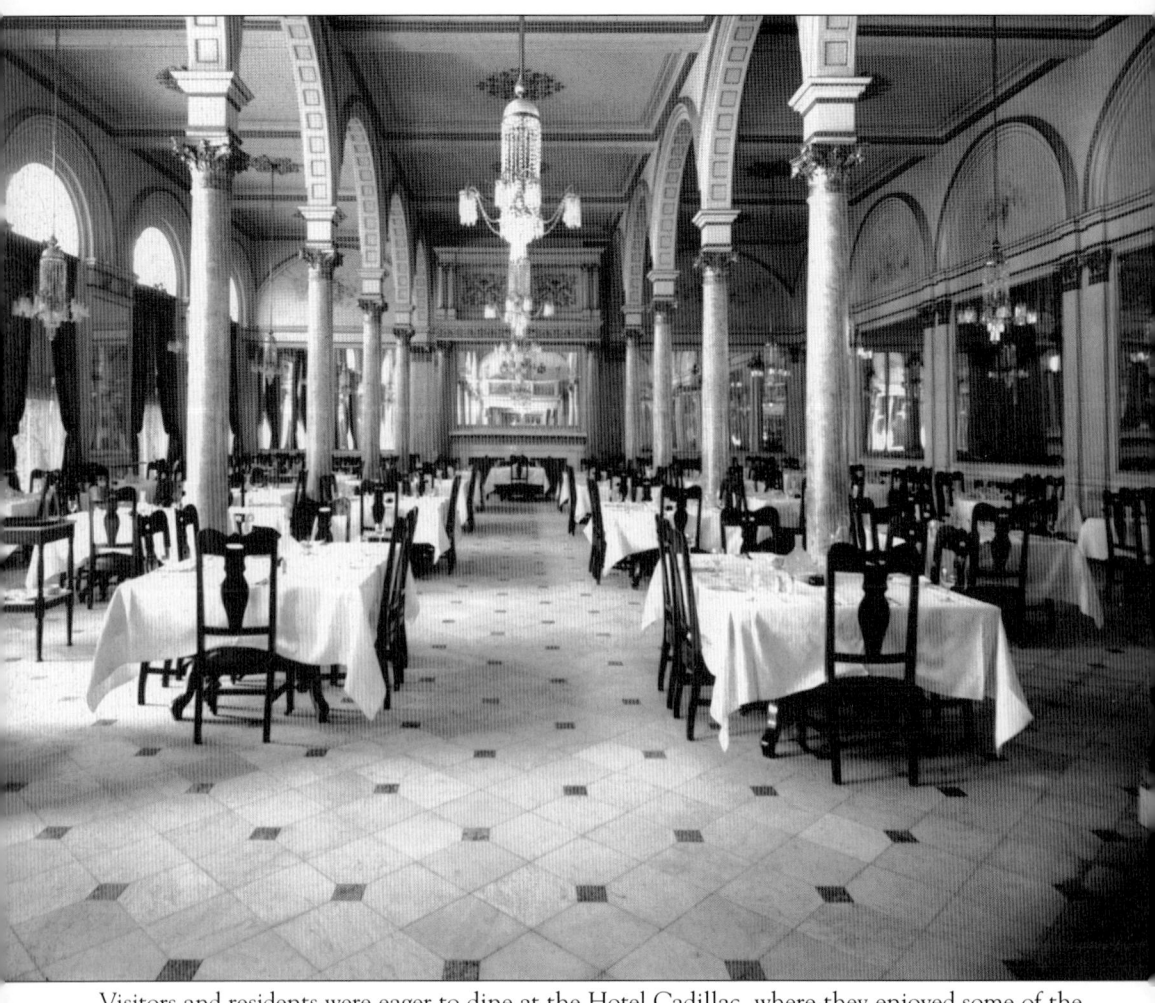

Visitors and residents were eager to dine at the Hotel Cadillac, where they enjoyed some of the best food and drink available in the city. Many patrons stayed for after-dinner dancing; a hotel orchestra played nightly for patrons who wanted to step out on the floor. (Courtesy of the Library of Congress.)

Male patrons enjoyed liquor, cigars, and atmosphere in the Hotel Cadillac's bar, but ladies and gentlemen could relax in its elegant red room together. Comfortable seating and a cozy atmosphere coexisted with tasteful decorative details like fluted columns, potted plants, and dramatic wall color. (Courtesy of the Library of Congress.)

The Griswold Hotel remained a desired destination for residents and visitors alike throughout the early years of the 20th century. Men lounge here in its comfortable yet impressive lobby. (Courtesy of the Library of Congress.)

Like other leisure destinations in Detroit and throughout the country, the Griswold Hotel provided separate dining and drinking areas for men and women well into the 1900s. Gentlemen and ladies dined together by candlelight in the hotel's café, but only men drank, smoked cigars, and played cards in the hotel's bar. (Courtesy of the Burton Historical Collection, Detroit Public Library.)

Three

THE ERA OF THE ELEGANT SALOON

With its well-stocked bar, beamed ceilings, polished brass rail, and white-coated bartenders, Miller's epitomizes the elegant drinking establishments typical of early-20th-century Detroit. The many brass spittoons, positioned on the floor at regular intervals, remind the viewer that saloons such as these catered to male patrons only. (Courtesy of the Burton Historical Collection, Detroit Public Library.)

One of the last of Detroit's old log saloons belonged to Bobby Trott and was located on the river near Jefferson Avenue, far from the bustle of the Campus Martius. Like the elegant Rail-Road and National Hotels, Trott also provided overnight accommodations at his small drinking establishment, but in a much more rustic setting. Taken in 1861, this photograph reminds viewers that the portions of Detroit in the early to mid-19th century still retained the Wild West character of a frontier town. (Courtesy of the Walter P. Reuther Library, Wayne State University.)

Charles Ranspach's expansive saloon, located on Michigan Avenue on the outskirts of the city in 1876, provided residents with an entertainment destination away from the congestion of the Detroit's business district. (Courtesy of the Burton Historical Collection, Detroit Public Library.)

SALOON & SUMMER GARDEN OF C. KLOENHAMMER, MICHIGAN AV, DETROIT.

An elaborate scrolled cornice adorned the otherwise modest building that contained Jacob Rupp's saloon, which he ran with his wife and immediate family during the late 1880s. The building was located, inauspiciously, across from the house of corrections, on Russell Street near Detroit's Eastern Market. Jacob Rupp most likely worked for the Westphalia Brewery; his name appears on the back of a photograph of the brewery's workers. (Courtesy of the Burton Historical Collection, Detroit Public Library.)

In 1827, a Maj. David McKinstry opened the city's first public amusement garden in the fruit orchard located between Randolph, Brush, Lafayette, and Monroe Streets. By the mid-1870s, residents flocked to summer gardens like Kloenhammer's, near the river, for a break from the city's crowds and congestion. Children ran through pastures here while adults strolled in gardens, drank beer (men only), and soaked in hydropathic mineral baths. One could even hear Kloenhammer's orchestra while reclining in the tub. (Courtesy of the Burton Historical Collection, Detroit Public Library.)

American Indians had prized the waters the Detroit River for its medicinal properties long before the French arrived. In the late 1860s, Detroit's German immigrants, too, were drawn to the waters, but for entertainment rather than health reasons. Summer gardens like Henry J. Carsten's catered to whole families, but Prohibition reformers disapproved of the atmosphere of these places, where women and children entertained themselves in the presence of men drinking. (Courtesy of the Burton Historical Collection, Detroit Public Library.)

A John Kartsen opened a saloon, restaurant, and cafeteria downtown in February 1915. His new establishment contained all the elements typical of upscale saloons of the period, intended to serve the wealthier clientele frequenting the theater district on Woodward Avenue and Washington Boulevard areas, east of Cass Avenue. Kartsen's Cascade Room, serving both men and women, provided waitress service, while the cafeteria remained self-serve. (Courtesy of the Burton Historical Collection, Detroit Public Library.)

R. EIPPER,
Saloon & Restaurant
33 Silver St., Cor. Russell St.,
DETROIT, MICH

Beginning in the 1850s, saloon owners like R. Eipper and Herman Petzold began advertising their establishments with colorful and cleverly printed advertisements like this one. During this time, patrons in Detroit had a particular taste for seafood delicacies imported from the East, such as oysters, sea turtles, and clams. Seafood left New York in special ice-filled railway cars and arrived at Detroit's Eastern Market, where proprietors bought it for that day's menu. One saloon owner advertised in 1851 that he had purchased a "fine, fat, lively Bahamian green sea turtle of immense size," which patrons could inspect on his premises for a week before he served it up in "the New York style" for two shillings per dish. (Courtesy of the Detroit Historical Museum.)

HERMAN PETZOLD,
Grocery & Saloon
379 Dubois Cor. Antietam St.
All Orders Attended To

Michael Miller's grocery store, beer hall, and saloon at 479 Elmwood Street had been open for nine years by the time this photograph was taken in 1900. A devoted family man and alderman of Detroit's 13th Ward, Miller had just been elected president pro tempore of the Detroit City Council on the evening prior to a serious accident that would end his life on July 22, 1901. As Miller was lighting carriage lamps, the horse bolted and crushed Miller's skull as he lay on the pavement. (Courtesy of the Burton Historical Collection, Detroit Public Library.)

Peter P. Zewe's at 388 East Congress Street possessed all the elements of an elegant pre-Prohibition saloon that served the business community: an elaborately outfitted bar, beamed ceilings, mustached waiters dressed in white shirts and black ties, a polished brass rail, and the ubiquitous free lunch counter located at the right. (Courtesy of the Detroit Historical Museum.)

The Parker House, located at Congress and Shelby Streets, may have appeared to be an ordinary neighborhood watering hole in 1890, but it occupied land that had once been part of Detroit's French and British forts and, later, the site of a stop on the Underground Railroad to Canada. The top of the Lennane Brothers Brewery is just visible above the building. The Western Union telegraph building replaced the Parker House in 1926. (Courtesy of the Burton Historical Collection, Detroit Public Library.)

The Heinz House, a two-story brick saloon on Orleans Street, was just one of the many drinking destinations available to workingmen in Detroit in the early 1900s. In an era when entertainment options were limited, men often went to their neighborhood saloon several times a day to eat, socialize, and play cards. Already by the dawn of the 20th century, telegraph poles had begun to obscure and clutter the urban landscape. (Courtesy of the Burton Historical Collection, Detroit Public Library.)

Among those patronizing the saloon owned by John C. Scheutz were clients whose horses were being serviced by the blacksmith next door. Scheutz's place would have provided a welcome distraction and a pleasant place to pass the time during one of 19th-century life's unavoidable delays. (Courtesy of the Burton Historical Collection, Detroit Public Library.)

The Stag Café provided the usual diversions for male clients—a place to consume beer and liquor, smoke cigars, and converse in an atmosphere of neighborhood collegiality. Customers could step next door to the cigar store to purchase additional smoking materials when necessary. (Courtesy of the Walter P. Reuther Library, Wayne State University.)

Men came to coif beverages, enjoy free food, and socialize at Fred McCurdy's Bar, located at the corner of Grand River and Cass Avenues, around 1915. This photograph shows numerous workingmen gathered in front of McCurdy's and in the doorways of saloons on adjacent streets as well. (Courtesy of the Burton Historical Collection, Detroit Public Library.)

Berman's Bar offered much to keep patrons in 1900 entertained—a café for dining, a bar with a separate entrance for male clients, and cabarets that ran morning and evening. (Courtesy of the Walter P. Reuther Library, Wayne State University.)

From the 1850s through the late 1890s, men attending the theaters lining Woodward Avenue often ducked into neighboring saloons like Ardussi's Garibaldi Saloon, at 20 Monroe Street, for a late supper of stuffed peppers, Chianti, and spaghetti. In defense of going to bed on a full stomach, one saloon owner wrote in 1852, "It is a mere mistake to condemn Suppers . . . Animals stuff immediately previous to sleeping; why should men be afraid of a few trifling turkey-legs or a bottle of London Ale or Porter?" In this photograph, proprietor Charles Ardussi presides over a bowl used to make Tom and Jerrys, a popular variation on rum-based eggnog developed in England during the 1820s. (Courtesy of the Walter P. Reuther Library, Wayne State University.)

Billiard tables began appearing at saloons like William Buesser's during the mid-1850s, in response to the newest craze emerging in New York and other eastern cities. Michigan's Gov. Lewis Cass did not approve of this activity, however, and declared on many occasions that "the playing of billiards might be injurious to the habits and morals of the community." Places like Buesser's typically had the dining parlor in one building, and two great evils—beer and pool—could be found just next door. (Courtesy of the Burton Historical Collection, Detroit Public Library.)

Woodward Avenue and Columbus Street had not yet been paved in 1915, during the time that the Hotel Delmar and its Woodward Bar provided lodging and alcohol to residents and travelers alike. (Courtesy of the Burton Historical Collection, Detroit Public Library.)

The brass spittoons placed at regular intervals on the floor of this elegant saloon serve as a reminder that cigar smoking, tobacco chewing, and beer drinking remained intimately connected in this male-dominated world. Many saloons also provided towels for patrons to wipe their hands and mouths after expectorating. Although currently empty, one senses that it would not be long before the place became filled with smoke and loud conversation. (Courtesy of the Burton Historical Collection, Detroit Public Library.)

LOG CABIN CAFE
OTTO HUCK PROP.
65 MICHIGAN AVE. DETROIT MICH.

Otto Huck's Log Cabin Saloon on Michigan Avenue sported a rustic hunting theme around 1909. Most likely located in or adjacent to a burlesque theater, the Log Cabin bar sported a sign that notified customers of a bell that rang "three minutes before curtain rises." Stuffed game, parchment lighting, deer antlers, and the saloon's signature hollowed-out log bar complete the rustic mood of this masculine drinking establishment. This postcard of Otto Huck's after hours highlights the saloon's masculine decor. In addition to theatergoers, workingmen, who did not have access to exclusive clubs, came into their neighborhood bars as many as three times a day for meals and socializing. (Courtesy of the Detroit Historical Museum.)

The decor employed at Otto Tank's Y Cafe at Myrtle and Roosevelt Streets was similarly masculine in design and appeal. Social decorum prohibited ladies from entering a barroom without seating, and an establishment had to provide dining tables and food in order to accommodate them. Otto Tank included a few tables, but the area in the immediate vicinity of the bar remained open, seemingly to serve as many standing male drinkers as possible. (Courtesy of the Detroit Historical Museum.)

Employees of the Polus Café pose for a photograph on a snow-covered street in the early years of the 20th century. Saloon owners frequently rented space on the first level or in the basement of commercial businesses or hotels. (Courtesy of the Detroit Historical Museum.)

The neighborhood bar functioned as a kind of social club for the workingman, who visited places like C. D. Seely's as many as three times per day to eat meals, greet friends, and play cards or darts. Usually located on or near a corner, the workingman's saloon could be recognized by its striped awning and near-empty beer barrels on the exterior. A glass of beer cost 5¢, and whiskey, which patrons drank straight, cost 15¢. (Courtesy of the Burton Historical Collection, Detroit Public Library.)

A saloon at the corner of Cadillac Square and Bates Street in 1910 provided alcohol of every kind for the working male population of Detroit; multiple signs promise bottled beer or old Kentucky whiskey, "from distiller to you." (Courtesy of the Burton Historical Collection, Detroit Public Library.)

The clock commemorating the site of Ernst Kern's 1888 dry goods store today stands at Woodward Avenue and State Street on the location of what had been one of Detroit's most elegant saloons—Churchill's. Liquor importer and owner Marvin Preston was married to a key organizer of Detroit's women's temperance movement and thus had to be discreet when indulging his love of fine wines and cigars. Using New York's elegant bars as a model, Preston put his fashionable establishment in the name of his manager, Charlie Churchill, and made himself a silent partner. Churchill's became legendary for a drink called the raspberry fizz (a mixture of fresh juice, soda, and vodka), for serving hors d'oeuvres with a napkin, and for Preston's extensive American paintings collection, which included a large-scale painting of a risqué nude that hung behind the bar. (Courtesy of the Walter P. Reuther Library, Wayne State University.)

It is not likely that proper Victorian ladies would have been found in establishments like the Gayety Theatre Rathskeller and Café at Cadillac Square and Bates Street around 1905. Men drinking in the theater bar did not have far to go to burlesque shows that ran during the day and evening hours. The prominent exterior fire escapes undoubtedly reassured patrons during a time when fires were an all-too-frequent occurrence. (Courtesy of the Burton Historical Collection, Detroit Public Library.)

Detroit, Mich.......................................

"THE BERLIN BAR" Fritz Schafus, Prop.
We keep the best of everything.
172 Michigan Avenue, near Second Street.
Tel Park 301-R.

Proprietor Fritz Schafus stands with employees and perhaps a patron outside his Berlin Bar in the early 1900s. By including bunting and German lettering over the saloon's windows, Schafus obviously intended his saloon to be a gathering place for fellow German emigrants to gather and socialize. (Courtesy of the Detroit Historical Museum.)

55

Proprietors, like the saloons they ran, were known for their distinct personalities and quirks. Few were as moral or noble as William W. Dolph, who ran a popular saloon at Woodward Avenue at Water Street. Dolph served the best beer in town and only beer (his window advertises Pfeiffer's). With the saloon's location in the upscale theater district, most of the clients coming and going from this establishment were gentlemen, and its owner insisted they behave as such. Unlike many saloon keepers, Dolph never served alcohol on Sundays and was reputed to be one of the few who never bent the rules once Prohibition hit. Note the quaint address on the doorway at the left, which says "4½." (Courtesy of the Walter P. Reuther Library, Wayne State University.)

By the 1870s, saloons and bars serving inexpensive, wholesome meals appeared everywhere. Detroit now supported a larger population traveling greater distances to get to their jobs. Workers, who could not make it home for a noon meal, now turned to local gathering places for a cheap hot lunch. One could buy anything from pork and beans for 5¢ to an elegant spread of about 35 items, with a napkin, for 50¢. Women rejoiced in their lightened workload, declaring the new restaurant policy to be "divine—an institution that gives us some of our rights!" Proprietor G. Poli provided tables for noontime dining on the right and at the end of the bar, where a sign announced the availability of free or cheap lunches. (Courtesy of the Burton Historical Collection, Detroit Public Library.)

Fred Becker served "celebrated" Goebel lager at his 7 Mile House in 1900. Saloons like this one attracted workingmen, who came there to drink, play card games, and—while this may not have been the case at Becker's—purchase female companionship. Patrons staying the night probably had to prepare themselves for less-than-elegant accommodations; Becker's appears rustic compared to the many more elegant establishments opening in Detroit during the same period. (Courtesy of the Burton Historical Collection, Detroit Public Library.)

Saloons like Luchow's offered drinks and meals to customers throughout the day and evening hours. The empty interior suggests that the photograph was taken before the lunchtime or evening rush, before noise and conversation disrupt the quiet. (Courtesy of the Burton Historical Collection, Detroit Public Library.)

The owner of the Cream of Michigan distinguished himself by opening Detroit's first self-serve cafeteria, but his place possessed all the elements of an elegant early-20th-century dining and drinking establishment in Detroit's theater district—cloth-covered tables and elegant lighting in the café area, where men and women dined together, and a well-stocked bar reserved for male patrons to discuss the news of the day over drinks and cigars. (Courtesy of the Burton Historical Collection, Detroit Public Library.)

Far from idealizing the effects of alcohol, saloon owner Walter Percival used advertising trade cards to poke fun at the vagaries of life while promoting the neighborhood watering hole as an escape from the drudgery of everyday responsibilities. A spat between husband and wife symbolizes the eternal battle of the sexes, two patrons lean on each other, having indulged in "one beer too many," and the man in a top hat on page 61 uses a lamppost to get his bearings after a long night drinking. (Courtesy of the Detroit Historical Museum.)

In addition to promoting saloons like Percival's, these trade cards also illustrate the interdependence of the brewing and cigar industries. Saloon owners, who often sold their own brand of cigars to patrons, proved to be among the cigar manufacturers' best customers. (Courtesy of the Detroit Historical Museum.)

When it opened in 1907 at Lafayette and Shelby Streets, many thought Fred Striker's saloon was too far from the city's business center to be a success. But by 1911, the Hofbrau Haus (loosely translated from the German to mean "fit for a king") enjoyed an enormous clientele and had already been renovated twice. Striker's workers revered him as much as his patrons did; every employee, from the bartenders to the dishwashers, shared in the saloon's profits. (Courtesy of the Burton Historical Collection, Detroit Public Library.)

By the early 1900s, Detroiters had more than 1,400 drinking establishments to choose from—one for every 70 men over the age of 20. The finer places, located along Woodward Avenue in the theater district, catered to businessmen, performers, and newsmen. The upscale corner saloon in this photograph was subsidized by Anheuser-Busch, Budweiser, and Michelob, which would have subsidized the alcohol, food, and entertainment inside. A lone female pedestrian walks by, head adverted, as if reluctant to confront this male-dominated world. The place advertised New York newspapers for sale, but the men in bowler hats seem more intent on the start of the cabaret or burlesque show. The patrons on the left appears relaxed and content to read the announcements posted on the building's exterior, but the men on the right are eager for a peek inside and jostle one another for position in line. (Courtesy of the Burton Historical Collection, Detroit Public Library.)

Chef Louis Fleischer's famous ham hocks and sauerkraut, served at both lunch and dinner, helped make Fred Striker's the city's most popular German restaurant at the time. Of the four rooms available at Striker's, only two were appropriate for women customers. (Courtesy of the Burton Historical Collection, Detroit Public Library.)

The streets of early-20th-century Detroit bustled with activity; businessmen and women pushing baby carriages hustle past two gentlemen who seem unaffected by the city's hurried pace. Engaged in a leisurely discourse, the two seem poised to visit one of the many saloons visible on the opposite side of the street. (Courtesy of the Walter P. Reuther Library, Wayne State University.)

63

Like most of Detroit's elegant saloons of the 1880s and 1890s, Thomas Swan's offered everything from frog legs to imported beers and soft-shell crabs shipped in from the East Coast. Men dined on the first floor or smoked cigars in the bar, but ladies were relegated to a separate dining room on the second floor. (Courtesy of the Detroit Historical Museum.)

John Kar serves workingmen of Detroit's Hungarian neighborhood after a long day's work at his saloon at 2166 West Jefferson Avenue in 1908. Kar's patrons are dressed in what appears to be a uniform, suggesting that they worked for the same employer. Neighborhood watering holes like this one provided immigrants with an important connection to their homeland. (Courtesy of the Detroit Historical Museum.)

The Western Union Saloon and Restaurant on Woodward Avenue must have been a popular place in the 1890s; numerous wagons have pulled up in front of the building, where a sign promises a saloon, a restaurant, and separate dining rooms. (Courtesy of the Burton Historical Collection, Detroit Public Library.)

Detroit's cobbled streets bustled with wagons and pedestrian traffic during the early 1900s. Two wagons have pulled up in front of a working-class drinking establishment, perhaps preparing to unload beer kegs or food provisions. (Courtesy of the Burton Historical Collection, Detroit Public Library.)

Peter Lutz's boardinghouse and saloon most likely also catered to Detroit's working class, given the presence of discarded beer barrels on the sidewalk. The woman and children visible in the photograph were either members of the proprietor's family or boarders. Workingmen could get a free lunch inside the bar and a glass of beer for 5¢. If the patron could not afford the price, a cheaper beverage was available; saloon owners often mixed the dregs of brew at the bottom of barrels like these with water and served them to those who lacked the funds to pay for drinks. (Courtesy of the Walter P. Reuther Library, Wayne State University.)

Newspapermen, politicians, and artists alike came to Charlie Glaser's Eidelweiss Cafe on Broadway for "really good imported beers and German food." In this photograph, well-to-do men and women have disembarked their vehicles and are entering the imposing building together for an evening of food, drink, and entertainment. Both sexes sat together in Glaser's café or dining room, where the beamed ceiling and wooden furnishings suggested an old English inn. (Courtesy of the Burton Historical Collection, Detroit Public Library.)

Detroit's bohemian population gathered nightly at Glaser's signature long bar (or *stamm tische*) well past Michigan's adoption of the Volstead Act; Glaser was one of many successful Detroit restaurateurs who refused to acknowledge the arrival of Prohibition. (Courtesy of the Burton Historical Collection, Detroit Public Library.)

67

Detroiters considered the Penobscot Inn to be one of the most elegant of the early-20th-century gathering places. The dining rooms and bar were among the first establishments in the country to feature washed air blown by fans over tons of ice. An African American waiter seats a wealthy patron, whose dinner companions are already at the table. The beamed ceiling and heavy wooden furniture suggest the decor of a European hotel. (Courtesy of the Burton Historical Collection, Detroit Public Library.)

Despite the Penobscot Inn's inclusion of the fairer sex, ladies still dined separately from the men in their own lunchroom on the building's second floor. If desired, patrons could stay overnight in well-appointed rooms upstairs. (Courtesy of the Burton Historical Collection, Detroit Public Library.)

George H. Gies's first commercial endeavor was a saloon and beer hall during the early 1880s, where men drank, smoked cigars, and listened to music. In the early 1900s, Gies opened a mainstream establishment more typical of the period: a hotel with rooms to let, a dining room for men and women, and a bar that catered to the entertainment of men only. (Courtesy of the Detroit Historical Museum.)

George Gies later closed his beer hall and opened the European Hotel and Restaurant around 1900. Like the other great saloon proprietors of the day, Gies obtained and served nothing but the best in the way of wines and liquors, cigars, seafood, game, and poultry. (Courtesy of the Burton Historical Collection, Detroit Public Library.)

69

GIES' RESTAURANT—Exterior. GIES' RESTAURANT—Interior.

Gies's new European Hotel was a much more elaborate business venture that catered to both residents and visitors to Detroit. Like most upscale establishments of the period, Gies's offered a restaurant and café in one building and a saloon strictly for men in the other. (Courtesy of the Detroit Historical Museum.)

Historian and teetotaler Clarence Burton once wrote that when he first arrived in Detroit in the 1860s, he went to Gies's saloon not for the liquor but for the music; the proprietor played the orchestrion—a cross between a player piano and a pipe organ that functioned as the jukebox of the day—for his patrons on a nightly basis. Undoubtedly, Gies's orchestrion was similar to the one featured in this early-20th-century saloon. (Courtesy of the Burton Historical Collection, Detroit Public Library.)

Sharpe's Chop House at Jefferson Avenue and Griswold Street stood on what most considered to be the actual landing site of Detroit's founder, Antoine de la Mothe, sieur de Cadillac. A favorite with sports enthusiasts and newspapermen, Sharpe's carried on the city's British tradition of serving English fare and spirits. Well past the early 1900s, residents considered Sharpe's to be the most celebrated chophouse in town and a favorite with sports and political figures of the day. (Courtesy of the Burton Historical Collection, Detroit Public Library.)

William C. Klenk's Headquarters Cafe enjoyed a loyal following in Detroit's theater district in the years leading up to World War I. In addition to offering patrons a bully menu that included cigars and alcohol, the café facilitated gambling by providing wire connections to baseball games and boxing matches. On the menu's cover, Klenk clutches a pressurized soda-water dispenser—the device that revolutionized the making of both ice-cream sodas and mixed alcoholic drinks. Clearly the proprietor wanted his saloon in the theater district to be a reflection of his individual personality and considered it important for his customers, mostly fellow German immigrants, to know him personally. (Courtesy of the Detroit Historical Museum.)

∴ The ∴
Headquarters Cafe

Wm. C. Klenk, Proprietor

29 MICHIGAN AVENUE
OPPOSITE WHITNEY'S
14 LAFAYETTE AVENUE
OPP. LAFAYETTE THEATRE
DETROIT, MICH.

TELEPHONE MAIN 2150

SPECIAL WIRE CONNECTIONS OF RING SIDES, BALL FIELDS FOOT BALL, ETC.

OUR BAR HAS ONE OF THE MOST AND BEST EQUIPPED LINE OF WET GOODS, COMPLETE OUTFIT OF SMOKERS' ARTICLES IN CONNECTION

AND YOU KNOW WHAT BULLY GOOD THINGS WE GOT TO EAT.

H. F. Loeweke & Co. Printers, 31 Farmer St

Throughout its history, Detroit remained a favored immigrant destination for many ethnic groups. The Irish began arriving in the 1830s, followed in the 1840s by the first wave of African Americans fleeing slavery in the South for safety in the northern United States and Canada. After the influx of northern Europeans entering in the 1850s and 1860s, Chinese immigrants fleeing ethnic discrimination in western states began arriving in Detroit around 1870. Many others followed during the late 19th and early 20th centuries from Europe, South America, and the Middle East. King Ying Lo was one of the few Chinese restaurants open in Detroit during the early 1900s. (Courtesy of the Burton Historical Collection, Detroit Public Library.)

Four

DETROIT'S CIGAR INDUSTRY

Many credit Civil War soldiers for the popularity of cigars. Enlisted men smoked mostly segars—an inferior product made with cheaper tobacco. German-born Anthony (Tony) Muer began making cigars in the 1870s in a shop at his residence at 34 Jay Street, on Detroit's east side. Muer's products became well known for their high-quality tobacco, which its owner grew locally. Tony Muer also became an institution for his particular method of delivery: a surrey drawn by two golden ponies. (Courtesy of Joe Muer.)

Muer cigars included the Swift, the Joe Muer, the Judge Gainey, and some private labels. After Tony Muer's death, his eldest son, Joseph (Joe), moved the business to his father-in-law's building at 1996 Gratiot Avenue in 1906. Joe Muer continued his father's mandate to represent cigar smoking as stylish but not exclusive. Joe proudly samples a Swift here outside his cigar shop. (Courtesy of Joe Muer.)

Civil War soldiers had been smoking cheaper cigar products (segars) since the mid-1860s. Like his father, Joe Muer felt that every man was entitled to the air of confidence and prosperity that cigar smoking promoted and remained committed to keeping his products affordable and accessible. (Courtesy of Joe Muer.)

In an inspired bit of marketing genius, Joe Muer used a caricature of himself in this Swift cigar advertisement, along with the slogan "Nothing fancy but the tobacco." (Courtesy of Joe Muer.)

Joe Muer played in a beer hall band with many close friends and fellow second-generation German immigrants. During the early years of automobile travel, the group played in town but often took the music on the road. In 1905, it appeared at the opening Tigers baseball game at Detroit's Bennett Park. (Courtesy of Joe Muer.)

This photograph shows Muer cigar factory employees (many of them women) sorting tobacco leaves during production. During the growing process, workers removed the flowers so that the flavor concentrated in the leaves. These were then allowed to air-dry, but the workers then had to wait for wet weather to rehydrate the brittle leaves before sorting, bunching, and stacking them for fermentation. The invention of cigar-rolling machines proved devastating for producers like Joe Muer, who rolled cigars by hand. (Courtesy of Joe Muer.)

Five
DETROIT'S BREWING INDUSTRY

The Stroh family—one of the most notable in Detroit's brewing history—began making beer in Germany in 1760. Fleeing the revolution in his homeland, 28-year-old Bernhard Stroh brought his family to Detroit in 1850 and immediately opened a business of his own. This photograph shows the Stroh factory on Gratiot Avenue and Rivard Road around 1885, located directly next door to the family home (not pictured). Trinity Lutheran Church is in the background. (Courtesy of the Burton Historical Collection, Detroit Public Library.)

In 1908, Bernhard Stroh's grandson Julius began using a direct-flame brewing process invented in pre–world war Europe. He built this sprawling Richardsonian Romanesque Revival house on Lake Shore Drive in nearby Grosse Pointe Farms around 1890. (Courtesy of the Burton Historical Collection, Detroit Public Library.)

In addition to making beer, Detroit breweries such as Stroh, Pabst, and Schlitz owned and operated a number of saloons in Michigan and throughout the Midwest. Breweries made it easy for the saloon keeper to run an establishment—they provided most of the beer, alcohol, and free food served in their saloons. Each brewery delivered products to its respective retail locations in marked trucks like the one pictured here. (Courtesy of the Burton Historical Collection, Detroit Public Library.)

Detroit brewers such as Melchers and Koppitz advertised to distinguish themselves from their competitors, selecting a trademark or symbol to represent the company. Bernhard Stroh modified and adopted the lion crest of a German castle near his childhood home; Melchers kept it simple by using the capital letter M. (Courtesy of the Detroit Historical Museum.)

For his advertisement, E. W. Voigt chose to represent the exterior of his factory set against the panorama of a bustling Detroit in the background. Some horse-drawn wagons deliver supplies and empty barrels to the factory entrance; others depart loaded with the finished product. Voigt later purchased huge parcels of land outside the city limits, which were developed later into some of Detroit's first residential neighborhoods in the early 1920s. (Courtesy of the Detroit Historical Museum.)

The Phillip Kling and Peninsular Brewing Company opened in 1865. That year, U.S. breweries produced around one million barrels of beer. By 1875, that number increased to around eight million barrels, due to innovations in brewery equipment. Post–World War II financial worries forced many Detroit-area breweries, including Kling, to close their doors in what historians call the Great Shakeout. (Courtesy of the Burton Historical Collection, Detroit Public Library.)

By the 1870s, most Detroit breweries had three floors and a cellar, but the Marx Brothers factory more closely resembled the one-story sheds of the 18th century, when beer was made mostly by hand. The Marx company grew to be the fifth-largest in Detroit by 1915. (Courtesy of the Burton Historical Collection, Detroit Public Library.)

This worker at the Marx Brewery plant operates the company's bottling machine, which revolutionized beer production after repeal of the Volstead Act. Most pre-Prohibition breweries that could not afford the expensive equipment hired a separate company to bottle and ship their products in reusable glass. (Courtesy of the Burton Historical Collection, Detroit Public Library.)

This Marx Brewery worker examines the giant vats, or coppers, used during the fermenting process. Hops are added to a mixture of malt sugar and water called wart and then boiled for 150 minutes to kill germs. Wart gives beer its distinctive bitterness and flavor. (Courtesy of the Burton Historical Collection, Detroit Public Library.)

Workers at the Westphalia Brewery gather for a photograph. Like Stroh's, Melchers, Voigt's, and other Detroit companies, Westphalia produced a light-colored, slightly sweet lager beer. The men appear with beer barrels and brewing tools; one man holds a dog in his lap. Written on the back of the photograph in pencil are the words "Jacob Rupp," suggesting that saloon owner Rupp may have worked for Westphalia and appears in the photograph with his coworkers. (Courtesy of the Burton Historical Collection, Detroit Public Library.)

Six

TEMPERANCE AND PROHIBITION

By 1911, 40 of Michigan's 83 counties had adopted the Volstead Act, but the remaining counties did not approve the resolution for another six years. By May 1, 1917, the rest of the state went dry, and Prohibition committees like this one attempted to ensure that Michigan stayed that way. The group assembled in an effort to control the city's ever-growing number of blind pigs. (Courtesy of the Walter P. Reuther Library, Wayne State University.)

In an attempt to slow the momentum of Prohibition, saloon owners used advertising to encourage business and even to portray beer as a kind of miracle beverage for people of all ages. Proprietor George Gies went so far as to promote beer as an appropriate drink for a baby in its highchair and a substitute for mother's milk. Far from being harmed by the consumption of alcohol, the infant and the nursing mother seem better off for downing their sizeable portions of the "amber fluid mild." (Courtesy of the Detroit Historical Museum.)

Drinking beer, according to saloon owner George Gies, will make the schoolboy grow up strong and bring wealth to the businessman. Undoubtedly, advertisements such as this, which advocated giving alcohol to young children, only fueled the anger of mothers and righteous members of Detroit's Women's Christian Temperance Association. (Courtesy of the Detroit Historical Museum.)

According to George Gies, drinking beer had a positive effect on people at every stage of life, including the elderly. His anti-Prohibition efforts extended to quoting the text of the Book of Common Prayer, which states that nature provides fruit exclusively for human consumption and for fermenting purposes. Gies seems to suggest that the human race has an obligation to create wine and beer; nature itself is "against Prohibition" and people are entitled to enjoy the fruit of the vine "in due time." (Courtesy of the Detroit Historical Museum.)

The temperance movement in the United States began as a movement initiated by women's groups and religious organizations to limit the consumption of alcohol to beer only. By 1900, however, the movement became increasingly more radical as members attempted to abolish liquor altogether. Whether to express their concerns or to vent their resentment at being denied access to this male world, women's groups frequently put on performances that portrayed saloons and their patrons as undermining the stability of life and home. (Courtesy of the Detroit Historical Museum.)

Prohibition ballots and propaganda, distributed at factories and manufacturing plants throughout Detroit, played on the deep-rooted fears of citizens who associated alcohol with the destruction of the American family. It would not take long, the activists argued, for saloons to corrupt what society valued most—its young boys. (Courtesy of the Detroit Historical Museum.)

Wealthy churchgoing Detroiters like dime store magnate S. S. Kresge and automakers Henry M. Leland and Henry Ford brought fiery Prohibitionist Billy Sunday (center) to Detroit to lecture before a million people in September 1916. Sunday ranted about the evils of drinking from inside an elaborate wooden tabernacle constructed for the occasion in a field between Woodward and Cass Avenues at Forest Street. His pronouncements clearly made an impact on the listening public; that November, Michigan voted 353,373 to 284,754 in favor of Prohibition. (Courtesy of the Burton Historical Collection, Detroit Public Library.)

Goebel and other brewers were aggressive in their efforts to present beer drinking as healthful and harmless. This Goebel playing card serves as a marketing tool both for the company and for the anti-Prohibition effort; the man represented here, dressed in traditional Bavarian garb, is mature but robust, having reaped the benefits of a lifetime of beer drinking. The back of the playing card says that Goebel beer is "pure, palatable, and nutritious." (Courtesy of the Detroit Historical Museum.)

When Prohibition dealt a killer blow to his business, cigar manufacturer Joe Muer had to find other means with which to feed his growing family. He borrowed money from his friends and transformed the cigar factory at 1996 Gratiot Avenue into a restaurant. This photograph shows Muer (second from left) and his staff on opening day, October 27, 1929—the night before the stock market crash and the Great Depression. (Courtesy of Joe Muer.)

Most considered Joe Muer's to be the best seafood restaurant between New York and Chicago. The family-run business served a combination of traditional German fare and French dishes. Oysters arrived from the East by railway express, packed in ice and shipped in wooden barrels. Rye whiskeys remained popular throughout the 1930s, and Joe Muer's offered a wide selection of cocktails such as Manhattans, old fashions, and whiskey sours. (Courtesy of the Burton Historical Collection, Detroit Public Library.)

Owner Joe Muer himself invented the restaurant's signature drink—the ice-cream hummer. Rum and vodka were not on the menu, and patrons could not order French wines or drinks on the rocks until the 1960s. This photograph dates from 1986, two years before Joe Muer's closed its doors. (Courtesy of Joe Muer.)

Despite Prohibition-era law enforcement's devotion to "the supervision of personal morals and appetites," Detroiters drank well, ate well, and had a more lively nightlife than ever before. One *Detroit Saturday Night* writer commented that "the color, the tang, the ironic zest" made the constant felonies of the time more than worthwhile. Patrons flocked to speakeasies like the Powatan, at Davenport Street and Cass Avenue, after the reputable restaurants in town closed at 1:00 a.m. (Courtesy of the Detroit Historical Museum.)

The Old Pioneer

MEMBERSHIP CARD

Mr. *Norman L. Lewis Jr.*
IS A MEMBER IN GOOD STANDING

D. Boone,
Secretary

Club Rooms Open Daily 10 a. m. to 1 a. m.
2951 E. JEFFERSON FITZROY 9544

Speakeasies in large cities like Detroit were elaborate establishments that provided food, live music, floor shows, and striptease. Many of these could be found near the Detroit River at Woodbridge Street, in what became known as Rivertown. In order to drink at a speakeasy or blind pig, a patron had to be a member in good standing, and no one was admitted at the door without their valid membership card. (Courtesy of the Detroit Historical Museum.)

PHONE MEMBERS ONLY

THE
PAR FOUR
CLUB
STEAKS AND CHOPS

7502 WOODWARD, COR. CUSTER
ENTRANCE, 11 CUSTER

Unruly behavior was not tolerated at Prohibition-era clubs, and anyone behaving inappropriately was asked to leave. In fact, the speakeasy owes its name to this practice. Often run by organized crime, bartenders lived in constant fear of detection by the authorities and would tell a loud patron to be quiet and "speak easy." (Courtesy of the Detroit Historical Museum.)

Billy Bonshaw owned and ran the Bucket of Blood, a disreputable blind pig frequented by mobsters and the city's most disreputable characters. This raucous drinking establishment had been aptly named; police reports of the day suggest that knife fights, barroom brawls, and even murder were not uncommon occurrences at Bonshaw's. (Courtesy of the Walter P. Reuther Library, Wayne State University.)

Down-on-their-luck patrons who frequented the Bucket of Blood often traded ancient military rifles and American Indian powder kegs for liquor. These historical items, along with the occasional campaign poster promoting an anti-Prohibition candidate, constituted the blind pig's only interior decorations. (Courtesy of the Walter P. Reuther Library, Wayne State University.)

Seemingly gregarious Billy Bonshaw ran one of the most notorious blind pigs during Detroit's Prohibition years. Ironically, the Bucket of Blood did not survive to see the end of the 1930s; the building was torn down in 1934, one year after the repeal of the Volstead Act. (Courtesy of the Burton Historical Collection, Detroit Public Library.)

Detroiters ranked Moesta's Tavern at Jefferson Avenue and East Grand Boulevard—a popular destination during Prohibition and after—among the city's most famous saloons. (Courtesy of the Walter P. Reuther Library, Wayne State University.)

Liquor produced in stills like this one or brought in from Canada could be found in every basement, garage, or parking lot. Grocery store owners quickly discovered that they could make more money selling bootleg liquor than food staples. Doctors even filled out special forms to prescribe booze to their patients. One could find blind pigs—lower-class dives not to be confused with the more upscale speakeasies—on practically every Detroit street corner and all of them served alcohol made from illegal stills. The resulting rotgut or bathtub gin tasted terrible; the bartender added fruit juices and nonalcoholic gin to disguise the flavor. (Courtesy of the Walter P. Reuther Library, Wayne State University.)

Prohibition forced Detroit drinkers to be more resourceful in their attempts to locate alcohol, but they did not have to go far to find it. Many took day trips over the river to Canada to buy liquor, which they brought back with them in brown bags disguised as groceries. (Courtesy of the Walter P. Reuther Library, Wayne State University.)

Authorities determined that 75 percent of the country's alcohol supply during Prohibition came through Detroit from Canada. Smuggling and rum-running brought great wealth to those in charge. Mobsters like members of Detroit's notorious Purple Gang wasted no time in taking over the city's numerous blind pigs and thought nothing of shooting up an establishment whose owner refused to turn over 15 percent of the profits. (Courtesy of the Walter P. Reuther Library, Wayne State University.)

Often revelers chose to leave the downtown area for a night of gambling and guzzling at the many roadhouses in Canada or outside the city limits. Spotters in speakeasies and roadhouses like this one kept a constant watch out for the authorities from second-story windows or makeshift towers. Drinking paraphernalia could be stashed away behind a false wall or in a hidden cupboard at a moment's notice. (Courtesy of the Walter P. Reuther Library, Wayne State University.)

After the repeal of Prohibition in 1933, bartenders and patrons alike seem eager to participate openly once again in the nation's favorite pastime. Bartender Harry Murphy serves a gentleman at the Gate Cocktail Bar in 1934. According to posted signs, customers could order Chinese dinners and a variety of cocktails at reasonable prices. (Courtesy of the Walter P. Reuther Library, Wayne State University.)

In addition to spaghetti and meatballs, the J. B. Cocktail Bar served a variety of festive drinks to diners during the 1930s. According to the sign, those intending to continue the party elsewhere could purchase alcohol on a takeout basis. One patron got more than booze at J. B.'s, however; someone slipped him knockout drops and he died soon thereafter. (Courtesy of the Walter P. Reuther Library, Wayne State University.)

During May 1934, bartender Joe Bathy proudly displays his newly appointed drinking establishment, one year after repeal. In the wake of the restrictions of Prohibition and World War I before it, women smoking and drinking in public became more accepted. By the mid-1930s, the sight of them patronizing nightclubs unchaperoned and hoisting glasses of beer next to their male counterparts would not have raised any eyebrows. (Courtesy of the Walter P. Reuther Library, Wayne State University.)

The post-Prohibition years saw a resurgence in the popularity of beer gardens like the Green Gardens at 473 Brainard Street. Adirondack chairs placed in the shade of mature trees provided drinkers with the illusion of a respite from the cares of city life. (Courtesy of the Walter P. Reuther Library, Wayne State University.)

Seven

THE ERA OF THE COCKTAIL LOUNGE

The cocktail enjoys the distinction of being the first American food or beverage to gain recognition worldwide. Successful Detroit liquor importer G. Viviano published a series of cocktail books for patrons to buy, called Favorite Cocktails of Famous Hotels. This one specialized in signature drinks served at Detroit venues. (Courtesy of the Detroit Historical Museum.)

Pictured here are the covers of two cocktail books put out by G. Viviano. The popularity of cocktails exploded in the mid-1800s, due to the availability of cheaper ice and the invention of a gas compressor used for making bubbly mixers that was small enough to fit behind a bar. Whether its name derives from the "cock's ale" served during Colonial cockfights or to the bottom, or "cock's tail," of the ale barrel in an old tavern, the cocktail is firmly rooted in the rum punches and toddies brought to this country by European immigrants. (Courtesy of the Detroit Historical Museum.)

The craze for Polynesian-themed bars began in Los Angeles in the late 1940s, when a soldier returning from the South Pacific opened an establishment that served the exotic rum-based drinks and Cantonese dishes he had encountered overseas. At the Chin Tiki, Detroit's first tiki bar, patrons sipped mai tais and zombie cocktails served in special cups called tiki mugs amid palm trees, flaming torches, tropical masks, and girls in hula skirts. (Courtesy of the Burton Historical Collection, Detroit Public Library.)

The Tropics Lounge modeled itself after Polynesian-themed bars created in California and Hawaii after World War II. Offering a bit of the South Pacific in the Midwest, the Tropics soothed patrons with the sound of rain pattering on its famous Rainfall Bars and year-round air-conditioning. (Courtesy of the Detroit Historical Museum.)

WINE LIST

PADDOCK

THE WINNER

▼

2035-37 PARK AVENUE
Corner of Elizabeth
Telephone CLifford 1313
DETROIT, U. S. A.

The Paddock Lounge and Café provided its patrons with an extensive wine and cocktail list that identified the ingredients in egg nogs, flips, punches, and what many consider as the first cocktail—an absinthe drink called the sazerac. (Courtesy of the Detroit Historical Museum.)

Cocktails

PADDOCK SPECIAL	$.40
DRY MARTINI (Gin, French Vermouth, Orange Bitters)	.30
BRONX (Gin, French and Italian Vermouth, Orange Juice)	.35
MANHATTAN (Whiskey, Italian Vermouth, Angostura Bitters)	.35
ALEXANDER (Creme de Cocoa, Gin, Cream)	.40
BACCARDI (Bacardi Rum, Grenadine, Lime Juice)	.35
GIN AND IT (Gin, Italian Vermouth)	.35
OLD FASHION (Whiskey, Angostura Bitters, Fruit, Sugar)	.35
PINK LADY (Gin, White of Egg, Grenadine, Lemon Juice)	.40
COFFEE (Port Wine, Brandy, Egg, Sugar)	.40
SIDE CAR (Cointreau, Brandy, Lemon Juice)	.40
DUBONNET (Gin, Dubonnet, Orange, Bitters)	.35
JACK ROSE (Apple Brandy, Lime, Grenadine)	.35
STINGER (White Creme de Menthe, Brandy)	.40
CLOVER CLUB (Gin, Italian Vermouth, Cream, Lemon Juice, White of Egg, Grenadine)	.40
PERFECT (Gin, French and Italian Vermouth, Bitters)	.35
CHAMPAGNE SPECIAL (Sugar, Bitters, Champagne, Orange Peel)	.50
SARATOGA (Brandy, Italian Vermouth, Angostura Bitters, Syrup)	.40
SAZERAC (Whiskey, Absinthe, Sugar)	.45
PRESIDENTE (Baccardi Rum, Sugar, Grapefruit Juice)	.40

Egg Nogs, Flips and Punches
Egg Nogs

BRANDY (Egg, Sugar, Milk)	$.50
RUM (Egg, Sugar, Milk)	.50
WHISKEY (Egg, Sugar, Milk)	.50
SHERRY (Egg, Sugar, Milk)	.50

Flips

WHISKEY (Egg, Sugar, Lemon)	$.40
BRANDY	.45
RUM	.45
SHERRY	.35
PORT	.35
BONDED 16 YEAR OLD WHISKEY (Rye or Bourbon)	.45
CANADIAN BONDED WHISKEYS (Rye or Bourbon)	.45
BONDED 4 YEAR OLD WHISKEY (Rye or Bourbon)	.45

The Paddock Lounge's menu includes the Paddock's signature drink but does not divulge its ingredients. Patrons could order any of these beverages for around 40¢. (Courtesy of the Detroit Historical Museum.)

Detroit's Latin Quarter

America's Most Exciting Theatre Restaurant
Detroit Owned and Operated
Proudly Presents

BEATRICE KAY

Star of Stage, Screen and Radio

1. **SAILBOAT IN THE BLUE**
 Dorothy Dorben Dancers......Virginia Tiff, Vivian Sanda, Mary Paache, Betty True, Carol Donnawell, Skippy MacColl, Ronnie Morre, Elaine White, Duvene Riopelle, Marie O'Neill, Steffie Brenton.
 Featuring Shirley South

2. **LLOYD AND WILLIS**
 Exponents of the Dance

3. **WILKEY AND DARE**
 That Funny Pair

4. **TROPICAL MOODS**
 Dorothy Dorben Dancers
 Shirley South

5. **FRANK AND DELORES EVERS**
 Exponents of the Wire

6. **GENE BAYLOS**
 The Atomic Bomb of Comedy

7. **MEET ME IN ST. LOUIE**
 Dorothy Dorben Dancers

8. **BEATRICE KAY**
 STAR OF THE GAY NINETIES
 Beatrice invites you to shout out your favorite old song and join in with her for a bit of gay nineties fun and frolic.

9. Finale . . . Entire Cast

Music by Bob Strong and His Orchestra

Entire Production under the Supervision of Dorothy Dorben

Tom Montgomery at the Organ in the Cocktail Lounge

Detroit's jazz scene was born in elegant ballrooms like the Latin Quarter and the Oriole Terrace, which flourished during the 1920s and 1930s. In 1942, a cabaret-style saloon called the Latin Quarter Cabaret opened in New York, offering patrons elaborate floor shows, famous entertainers like Sammy Davis Jr., and beautifully dressed (or undressed) girls, in addition to food and liquor. The popularity of this kind of sophisticated entertainment spread, and Latin Quarter Cabarets opened in other cities like Detroit, bringing residents a taste of big-time jazz, radio, stage, and screen talent for the first time. Cabaret-style clubs eventually gave way to the swinger lounges of the 1960s and 1970s. (Courtesy of the Detroit Historical Museum.)

Elegant ballrooms and hotels held dances during the 1920s through the 1940s that became all the rage for young people eager for modernism in entertainment, fashion, and behavior following the dark years of World War I. Many of the best swing and jazz bands in the nation entertained Detroiters at elegant hotels like the Wayne, which featured both indoor and outdoor music and dancing. (Courtesy of the Burton Historical Collection, Detroit Public Library.)

The exterior of Wayne Hotel, located near the Detroit River, featured a pavilion adjacent to the main building that functioned as an outdoor entertainment venue for upscale parties and informal gatherings during the summer months. (Courtesy of the Library of Congress.)

Drawn by the promise of better jobs and good wages in Detroit's burgeoning automobile factories, African Americans began arriving from the South around 1908. Most of these workers settled in a five-block area east of Woodward Avenue in a residential area known as Black Bottom. By 1920, African Americans owned 350 businesses in the city, many of them on Hastings Street in the commercial area adjacent to Black Bottom called Paradise Valley. (Courtesy of the Burton Historical Collection, Detroit Public Library.)

AFTER THE GAME - - - - - MEET YOUR FRIENDS AT

The HORSESHOE BAR

606 East Adams

William T. Johnson
LeRoy A. Young
Props.

"In The Heart of Paradise Valley"

Named for the Asian Paradise trees growing along the fences that lined the neighborhood, Paradise Valley became the birthplace of Detroit's blues and R & B music scene. Beginning in the 1920s, some of the best local and nationally known talent came to play at places like the Paradise Theatre and the Horse Shoe Bar at 606 East Adams Street. Celebrities that patronized the Horse Shoe and other Paradise Valley venues included famed boxer Joe Lewis, who became a fixture at clubs on Hastings and Adams Streets. (Courtesy of the Burton Historical Collection, Detroit Public Library.)

Autographed photographs of talented performers decorated the walls of the Horse Shoe Bar during the 1920s, 1930s, and 1940s. Many of the noted artists that played at the club went on to enjoy fame throughout the Midwest and beyond. (Courtesy of the Burton Historical Collection, Detroit Public Library.)

Paradise Valley show bars from the 1920s to the 1960s were also called black and tan clubs, which meant that the talent performing was black but the audience attending consisted of both black and white patrons. The Flame Show Bar, which opened in 1949, attracted the best local and nationally known blues and R & B talent and became the most recognized of the Paradise Valley clubs. While patrons came from all over the country to see acts from out of town, they also came to see the Flame's house band, Maurice King and the Wolverines, whose leader later became famous during the rock-and-roll and Motown eras. (Courtesy of D. K. Peneny.)

The tart and "invigorating" Ramos gin fizz had its roots in New Orleans but made its way north during the cocktail era. While many cocktail lounges soon came up with their own version of the gin fizz, the National Hotel Management Company had exclusive rights to the original recipe in Detroit and offered it only at its one property in the city—the Book-Cadillac Hotel on Washington Boulevard. (Courtesy of the Detroit Historical Museum.)

HOTELS DIRECTED BY
NATIONAL HOTEL MANAGEMENT CO.
INCORPORATED

RALPH HITZ
PRESIDENT

NEW YORKER AND LEXINGTON
New York

BOOK-CADILLAC
Detroit

NETHERLAND PLAZA
Cincinnati

VAN CLEVE
Dayton

RITZ-CARLTON
Atlantic City

The Famous
RAMOS GIN FIZZ

• For generations visitors to New Orleans have come back with tales of a wondrous drink which could be secured only in the Crescent City. This snow-white delight, the original Ramos Gin Fizz, was the crowning achievement of Henry C. Ramos, the master mixologist of his time.

Today, through an exclusive arrangement with the Ramos family, this tangy, bracing drink may be enjoyed at all hotels directed by National Hotel Management Company, Inc. You can't imagine that a drink could ever be so smooth, so invigorating, so honestly **good,** until you've tried a Ramos Gin Fizz as made at our bars.

Detroiters frequented stylish cocktail lounges like this for drinks and entertainment or at the close of a night on the town. It possesses all the elements of a classic cocktail lounge interior: vinyl chairs in clean, simple shapes, a monochromatic color scheme, and understated lighting. (Courtesy of the Burton Historical Collection, Detroit Public Library.)

The Famous Door at 212 West Grand River Avenue was among the many Las Vegas–style cocktail lounges in downtown Detroit during the 1930s through the 1960s. This club, a classic example of lounge architecture both inside and out, earned its place in Detroit's distinguished music history as the venue for famous talent for many years. (Courtesy of the Burton Historical Collection, Detroit Public Library.)

Detroiters who patronized the Alamo and other distinguished cocktail lounges witnessed music history during the 1950s and 1960s. Despite the efforts of preservation groups, many of these historical places have fallen victim to the urban blight that has plagued Detroit since the 1970s. (Courtesy of the Burton Historical Collection, Detroit Public Library.)

Cocktail lounges like the Bowery Cafe proved distinctive as much for their architecture as for the drinks they served. The Bowery's exterior neon lights and marquee extols the talent of John "Hair of Gold" Laurenz, the blond-haired singer currently performing. (Courtesy of the Burton Historical Collection, Detroit Public Library.)

The extraordinary list of talent that played at El Sino, which includes the Sinoettes, the Bo Po Jo Dancers, and Ray Washington, helped put Detroit's Paradise Valley clubs at the forefront of music history from the 1920s through the 1960s. (Courtesy of the Burton Historical Collection, Detroit Public Library.)

The Brass Rail Theatre Bar enjoyed great popularity with patrons for after-work socializing and post-performance dining from the 1920s through the 1970s. (Courtesy of the Burton Historical Collection, Detroit Public Library.)

While patrons may have considered the interior of the Brass Rail Theatre Bar to be ordinary among Detroit's 1940s cocktail lounges, the same could not be said about its exterior. Renowned Michigan sculptor Leonard D. Jungwirth carved two life-size wooden Bavarian-style figures and placed them on either side of the Brass Rail's front door. When the bar closed in the 1970s, these impressive pieces were purchased and relocated to another bar in a Detroit suburb. (Courtesy of the Detroit Historical Museum.)

Men and women enjoy drinks at the Brass Rail on the evening of June 24, 1943, after the city lifted a ban on drinking imposed during a race riot that summer. Since the repeal of Prohibition in 1933, women felt free to express outwardly an independence that had been building since the close of World War I. No longer constrained by social conventions, women smoked and drank in public, wore what they wanted, and attended bars and clubs unchaperoned. (Courtesy of the Walter P. Reuther Library, Wayne State University.)

During August 1942, army officers and police in Detroit swept downtown bars and saloons in the first draft-dodger roundup of World War II. By the end of the summer, 13 establishments had been raided. Authorities conducted frequent checks for draft cards and closely monitored activities in big-city drinking establishments suspected to be hangouts for those attempting to evade military service. (Courtesy of the Burton Historical Collection, Detroit Public Library.)

Patrons and bar owners alike were undoubtedly not pleased when police burst into their local hangouts to check for draft cards. Drinkers unlucky enough to be caught in this establishment at 2:00 p.m. probably had much explaining to do, both at work and at home. (Courtesy of the Burton Historical Collection, Detroit Public Library.)

Not all bartenders and proprietors allowed their establishments to be hideouts for draft dodgers and derelicts. In March 1942, Conrad's Bar chose to celebrate and support Detroit's enlisted men by hanging a hat on the wall for every citizen who went off to fight. (Courtesy of the Burton Historical Collection, Detroit Public Library.)

Rosie Janeck opened the Recreation Bar in 1941 at 11162 Mack Avenue, on Detroit's east side. With her establishment located outside the gates of a Chrysler plant that remained active during the war, Janeck focused on attracting business from plant workers as they came and went from work. Her son, Ed, remarked that his mother's motto remained as follows: "You give away the beer; what you sell is atmosphere." (Courtesy of the Burton Historical Collection, Detroit Public Library.)

Buddy and Jimmy's Inn on Cass Avenue opened in wartime Detroit during the early 1940s. Francis Welch (left), Buddy Welch (center), and piano player Dewey Lee entertained patrons well into the 1960s. (Courtesy of the Burton Historical Collection, Detroit Public Library.)

Famed restaurateurs Les and Sam Gruber opened the London Chop House in 1938 in the basement of the Murphy Building. In an era when Detroit restaurants offered only German wines, Les Gruber became the first to import and serve French wines to his patrons. (Courtesy of the Walter P. Reuther Library, Wayne State University.)

Inside the Gruber brothers' famous London Chop House, checked cloths covered the tables and miles of character sketches lined the walls. The restaurant combined an elegant food and drink menu with a comfortable decor. By 1952, the wait for a table at the London Chop House grew so long that the Grubers opened the Caucus Club across the street to handle the overflow. Ironically, the Caucus Club outlived the London Chop House and still serves its signature vodka and bullion-based drinks—the bull shot and the bloody bull. The Caucus Club also earned a spot in the annals of entertainment history as the first paid singing venue for Barbra Streisand, who performed there in 1961. (Courtesy of the Burton Historical Collection, Detroit Public Library.)

London

CHOP HOUSE

My interest is in bringing together the pleasures of eating and drinking and offering them in a warm atmosphere, reminiscent of Old World Inns. Only the finest foods emanate from our kitchen, and our wine cellar is stocked full of chateau bottled vintage wines. In our mixed drinks Bonded liquors are used and we have every *good* liquor obtainable in Michigan. There is music and entertainment nightly from 8 P. M. until 1:30 A. M. Open Sundays and Holidays—dinner itself beginning at 3 P. M. If there is something you desire, any service we can render, you have but to ask!

Lester Gruber

155 West Congress St., Detroit, Mich.

The London Chop House's famous chef, Eddie Dobler, earned the title "the Perch King" for his exceptional handling of the standard Michigan delicacy—lake perch. The restaurant featured a full-scale English dinner at noon and music and entertainment nightly from 8:00 until 1:30. (Courtesy of the Burton Historical Collection, Detroit Public Library.)

John Butsicaris and his brother Jim opened the Lindell Athletic Club in 1949 in the old Lindell Hotel on Cass Avenue and Bagley Street, christening their establishment the first sports bar in America. The place moved down the street to Cass and Michigan Avenues in 1963. By the 1950s, the Lindell Athletic Club had become the destination for athletes like Mickey Mantle and Wilt Chamberlin and entertainers Milton Berle and Dean Martin, along with numerous actresses, politicians, judges, gamblers, and mobsters. Many who frequented the place during the bar's heyday recall some memorable postgame fistfights occurring between the members of Detroit sports teams and their opponents. Hundreds of fans celebrated with the Tigers the night Detroit won the 1968 American League pennant. The Lindell Athletic Club closed in 2002 and was later torn down to make way for a bus station. (Courtesy of the Walter P. Reuther Library, Wayne State University.)

During the late 1960s, racial conflicts and a slowing economy had a crippling effect on Detroit's downtown entertainment venues. Restaurants closed, and residents moved out to the suburbs. While some establishments managed to weather the storm, many downtown cocktail lounges and the individuals who patronized them showed visible signs of hard times. (Courtesy of the Burton Historical Collection, Detroit Public Library.)

Cliff Bell's Bar, a drinking establishment with a long, distinguished history, provided Detroiters with a glimmer of optimism by reopening its doors on Park Avenue in 2006, after an absence of 21 years. The club's originator, John Clifford Bell, had worked in his father's saloon from the age of 16 and later opened his own club nearby in 1935. Outfitted luxuriously with brass fixtures, mahogany paneling, and the latest in air-conditioning and refrigeration, Cliff Bell's place dominated the busy Park Avenue strip until Bell's retirement in 1958. (Courtesy of the Burton Historical Collection, Detroit Public Library.)

cliff bell's bar

> Now, boys, just a moment!
> You've all had your say;
> While enjoying yourselves
> In so pleasant a way.
> We have toasted our sweethearts
> Our friends and our wives;
> We've toasted each other,
> Wishing all merry lives;
> But I now will propose to you
> The toast that is best—
> 'Tis one in a million,
> And outshines all the rest.
> Don't frown when I tell you
> This toast beats all others;
> But drink one more toast, boys—
> A toast to—"Our Mothers!"

2030 park avenue
clifford 4141

● CLIFF BELL'S • DETROIT

Cliff Bell's offered great food and signature drinks throughout its tenure on Park Avenue. Bell's menu continued the long-standing saloon tradition of reminding patrons that a good son never forgets to drink to his absent mother. (Courtesy of the Detroit Historical Museum.)

Across America, People are Discovering Something Wonderful. *Their Heritage.*

Arcadia Publishing is the leading local history publisher in the United States. With more than 3,000 titles in print and hundreds of new titles released every year, Arcadia has extensive specialized experience chronicling the history of communities and celebrating America's hidden stories, bringing to life the people, places, and events from the past. To discover the history of other communities across the nation, please visit:

www.arcadiapublishing.com

Customized search tools allow you to find regional history books about the town where you grew up, the cities where your friends and family live, the town where your parents met, or even that retirement spot you've been dreaming about.